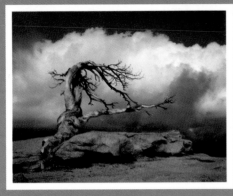

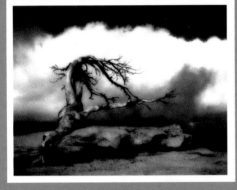

W9-AUO-943

The Digital Darkroom Guide

with Adobe® Photoshop®

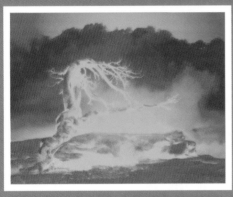

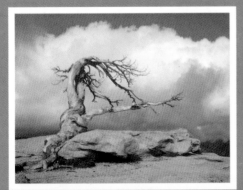

Maurice Hamilton

AMHERST MEDIA, INC. ■ BUFFALO, NY

Copyright © 2004 by Maurice Hamilton.
All photographs by the author.

All rights reserved.

Published by:
Amherst Media®
P.O. Box 586
Buffalo, N.Y. 14226
Fax: 716-874-4508
www.AmherstMedia.com

Publisher: Craig Alesse
Senior Editor/Production Manager: Michelle Perkins
Assistant Editor: Barbara A. Lynch-Johnt

ISBN: 1-58428-121-9
Library of Congress Control Number: 2003103032

Printed in Korea.
10 9 8 7 6 5 4 3 2 1

No part of this publication may be reproduced, stored, or transmitted in any form or by any means, electronic, mechanical, photocopied, recorded or otherwise, without prior written consent from the publisher.

Notice of Disclaimer: The information contained in this book is based on the author's experience and opinions. The author and publisher will not be held liable for the use or misuse of the information in this book.

FOR VIVIEN

About the Author

Maurice Hamilton is an award-winning landscape and nature photographer whose photography workshop is located in the historic gold rush town of Groveland, CA, near Yosemite National Park. Although he travels the world to photograph the beauty of exotic locations, Maurice specializes in images of the American West. He also sponsors Adobe® Photoshop® workshops that explore the concepts presented in this book. Information on Maurice's fine art images and Photoshop workshops is available at www.hamiltonphoto.com.

Contents

Introduction

The focus of this text will be the application of traditional darkroom techniques to the digital darkroom using Adobe Photoshop. In this book I will show you how to transform your own image files—whether from film or digital capture—into master files you can use to produce fine art prints from your own printer or a commercial LightJet printer. Although the techniques described in this book are appropriate for intermediate users of Photoshop, no prior experience with Photoshop is necessary.

The major decisions in establishing a digital darkroom relate to equipment, including the computer, operating system, monitor, scanner, and printer. This text provides recommendations for the digital darkroom and outlines the appropriate settings for scanning and printing images. Recognizing that an essential feature of the digital darkroom is a color-managed workflow that includes a properly calibrated monitor, I will also explain basic color theory and the optimal way to incorporate it into your workflow.

THE CORNERSTONE OF THE
DIGITAL DARKROOM IS
ADOBE PHOTOSHOP.

The cornerstone of the digital darkroom is Adobe Photoshop. This sophisticated software application provides such a broad spectrum of tools for creating and editing digital images that one could spend years mastering the techniques. For photographers, the time required to learn Photoshop competes with the time we need to acquire the images that form the basis for our work. Fortunately, as photographers, we need to learn only a relatively small proportion—perhaps 25–30%—of Photoshop's features in order to create outstanding digital prints. The essence of Photoshop is distilled for you in these pages.

To illustrate the steps required to create the master image file, I have included a number of examples from my portfolio. In addition, concepts

that can be utilized to create special effects in the digital darkroom are explored, including the transformation of color images into black & white prints.

Like Ansel Adams, I view the negative, or original image capture, as a musical score, and the printing of that image as the performance of a piece of music, which "may be of great variety and yet retain the essential concepts."[1] We will maintain the integrity of our images. This means that we will not change significant elements in an image unless this is clearly stated. Each person must decide for himself or herself what represents appropriate image editing. For the most part, though, our performance of the symphony will consist of adjusting the brightness, contrast, and color balance to optimize an image. As in the chemical darkroom, we may burn, dodge, and apply edge effects.

I prefer to avoid the term "modify" to describe these digital processes, as this may imply that the photograph was changed in an unnatural way. People do not generally consider that photographers "modify" their images while using traditional darkroom techniques, nor should we promote that misconception regarding our work in the digital darkroom. As with the chemical darkroom, "processing" most accurately characterizes our digital work. So let us now consider how to process a digital "negative" to produce a fine art print!

1. Ansel Adams. *The Negative*, no. 2 of The Ansel Adams Photography Series (Little, Brown and Company, 1995).

LIKE ANSEL ADAMS, I VIEW THE NEGATIVE, OR ORIGINAL IMAGE CAPTURE, AS A MUSICAL SCORE.

1. Digital Darkroom Equipment

COMPUTER

Most graphics artists and commercial laboratories use the Macintosh platform, whereas most "consumers" use PCs. Either will work, and the features within Photoshop are virtually identical for both systems. ICM, the color management system for Windows, is similar to—but not quite so transparent as—ColorSync, the color management system for Macintosh.

I recommend a 733 MHz or faster Macintosh computer or a 1.3 GHz or faster PC with a large hard drive and, more importantly, lots of RAM. Ideally, one should have three to five times as much RAM as the size of the largest image file. With insufficient RAM, Photoshop uses the hard drive as a disc cache, resulting in much slower image processing. At current prices, one can obtain 1.5GB RAM relatively inexpensively. Higher-end Macs offer 512MB RAM as part of the standard configuration, and some vendors will add another 512MB for a small installation fee.

CD-RW OR DVD DRIVE

For image storage, you will want to incorporate a CD-R, CD-RW, or DVD drive into your computer. Although CD-RW discs are not sufficiently reliable to be used for archiving images, CD-R discs can be created with a CD-RW drive. For archival storage, a high quality CD-R or DVD should be used.

Roxio (formerly Adaptec) Easy CD Creator software for burning CDs typically accompanies CD-R drives for PCs. Mac users may elect to purchase similar software known as Roxio Toast Titanium in order to exercise a comparable degree of control over the creation of CDs.

WITH INSUFFICIENT RAM, PHOTOSHOP USES THE HARD DRIVE AS A DISC CACHE.

MONITORS

Sony Trinitron, Mitsubishi Diamond, and LaCie Blue monitors are highly rated. ViewSonic monitors represent an option for the budget conscious. Monitors that allow you to adjust the individual RGB guns will provide the most accuracy in setting the white point during calibration. However, I have seen satisfactory results from a Trinitron monitor without these RGB controls.

I recommend seventeen-inch monitors as the minimum acceptable size—but prefer a larger screen. I have been quite satisfied with my Sony twenty-one-inch monitor, but it constitutes the most massive component of my system, weighing in at almost sixty-eight pounds. The newest LCD monitors provide a compact, though more expensive, alternative. Opinions differ as to whether one can achieve the same quality of monitor output with LCD as CRT monitors.

I also strongly suggest using a second monitor to display the Photoshop palettes. My system incorporates an Apple seventeen-inch LCD monitor, but most any monitor can be used. In this capacity, the monitor does not require calibration. Using two monitors will require either a dual graphics card (available from Matrox or NVIDIA) or an additional PCI graphics card (make sure you have an available slot). Describe your precise configuration (including CRT vs. LCD monitor) to your salesperson before ordering your graphics card to assure that everything will work as you expect.

I RECOMMEND SEVENTEEN-INCH MONITORS AS THE MINIMUM ACCEPTABLE SIZE.

MONITOR CALIBRATION SOFTWARE & HARDWARE

Perhaps the most critical aspect of the digital darkroom is a properly calibrated and profiled monitor. I recommend a calibration system that includes both software and hardware to measure monitor output.

A popular option is the Spyder colorimeter with PhotoCal software from Color Vision. PhotoCal requires that the observer set the monitor brightness visually based upon the appearance of four adjacent boxes. A somewhat more sophisticated version is called OptiCal. The original Color Vision products were designed to calibrate CRT but not LCD monitors. Current versions of the products permit calibration of either CRT or LCD monitors. Although the Color Vision products calibrate and profile only one monitor per computer, this is sufficient for most users. Details on the use of these products to create monitor profiles are provided below under Color Management: Profiles. A somewhat more expensive alternative, preferred by some, is the Eye-One Monitor spectrophotometer/software package from GretagMacbeth. Unlike PhotoCal or OptiCal, this system can calibrate and profile two system monitors, either CRT or LCD. GretagMacbeth also offers Eye-One Display, a colorimeter to calibrate and profile CRT or LCD monitors.

SCANNER

If one is working with film, as most of us still are, a transparency scanner should generally be incorporated into the digital laboratory. The sophistication and price of the scanner will depend upon the film format and the desired output size. Although several excellent high-resolution scanners are available, I have been impressed with the quality of the Nikon 8000ED scanner, which scans both 35mm and medium format film at 4000 dpi. For mounted 35mm transparencies, the Nikon 4000ED represents a good choice. If you do not plan to make prints larger than 13 x 19 inches, less expensive models that scan slides at 2900 dpi should be adequate.

PRINTER(S)

With the availability of relatively inexpensive, high-quality photographic inkjet printers from Epson and other companies, I strongly recommend the addition of a dye- or pigment-based printer to your digital lab. I have been pleased with the richness of colors on the dye prints from the Epson 1280 photographic printer using Epson Premium Luster photo paper. The profiles provided with this printer or downloaded from Epson's Web site have been sufficiently accurate that I have not needed to purchase separate printer profiles (although they are available from sources such as Chromix.com and Profilecity.com).

THE DISADVANTAGE OF DYE-BASED INKS IS THEIR LACK OF ARCHIVAL QUALITY.

The disadvantage of dye-based inks is their lack of archival quality. Although Epson has introduced a paper for dye-based inks called Color Life, which is projected to endure without significant fading for up to twenty-five years, prints on this paper seem to lack the tonal richness associated with Premium Luster. In contrast, pigment-based inks may be archival but have lacked the richness of dyes. As a compromise between the greater dynamic range of dye-based inks and the longevity of pigment-based inks, Epson developed a series of pigment-based printers that utilize seven (rather than the traditional four) "Ultrachrome" inks to produce prints that may be considered archival (more than fifty years when displayed under glass) yet possess a relatively broad dynamic range. One of these printers, the Stylus Photo 2200, can produce prints up to 13 x 19 inches (or up to 13 x 44 inches using roll paper). Many of us have added this new model to our digital darkroom, keeping the dye-based printer for proofs and prints where longevity is not an issue. For those with more expansive inclinations, other Epson printers use Ultrachrome inks to produce prints up to twenty-four or forty-four inches in width. The texture of canvas prints from these larger printers provides an interesting alternative to Luster photo paper.

In addition to printing images with inkjet printers, many of us also utilize our digital files to produce fine art prints from LightJet printers at a commercial lab. One advantage of such prints is that they can be produced in sizes up to 48 x 48 inches with the LightJet 5000 series, 50 x 120 inches with the LightJet 430 printer, and 76.5 x 120.5 inches with the LightJet

500XL. In addition, some clients may occasionally prefer a traditional photographic print such as a LightJet print to an inkjet print. Fortunately for us, some labs offer significantly discounted prices on prints from image files created as described in this text.

LIGHTING

In order to evaluate the tonality and color of images on the computer monitor, ambient lighting in the digital darkroom should be dim without bright sources of light within your field of vision or glare from the computer screen. Ideally, colors in the surroundings should be neutral.

In addition, to analyze prints and compare them to the display on your monitor, prints should be viewed under 5000° K lighting. This can be accomplished with overhead fluorescent lights of that temperature or, more precisely, with a Solux 4700° K light, which emits a spectrum similar to solar light. Likewise, transparencies should be viewed with a 5000° K light box.

IDEALLY, COLORS IN THE SURROUNDINGS SHOULD BE NEUTRAL.

2. Color Management

The primary purpose of color management is to make the colors from input devices (digital cameras and scanners) match the colors on output devices (monitors and printers). To accomplish this translation, three basic components are required: a reference color space, a profile for each device, and a color engine. Appropriate application of color management is essential for accurately processing images in the digital darkroom. Fortunately, the latest versions of Photoshop have simplified color management and made it easier to ascertain that one is working in the desired color space.

COLOR SPACES

A reference color space may be defined as a mathematical model used to represent color as perceived by the human eye. Current color management systems utilize two reference color spaces developed by the Commission Internationale De l'Eclairage (CIE). The first model, known as CIE XYZ, was created in 1931 to represent the spectrum of colors seen by the normal human eye. In this model, the lightness of a color is indicated by Y and its hue and saturation by the chromaticity coordinates x and y. However, the characterization of color in a Yxy diagram distorts the relationships between colors, such that red and violet colors are compressed compared to colors in the green portion of the spectrum.

In 1976, this model was refined as CIE L*A*B* (LAB). This new model represents different colors more uniformly and also encompasses the finding that color stimuli reach the brain as variances between light and dark, green and red, and blue and yellow (rather than red, green, and blue). The corresponding coordinates are called L, *a,* and *b*. In addition to CIE LAB, color models include HSB (hue, saturation, brightness), RGB (red, green,

APPROPRIATE APPLICATION OF COLOR MANAGEMENT IS ESSENTIAL....

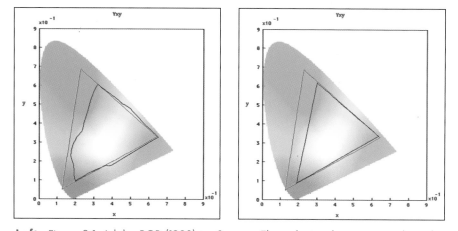

Left—Figure 2-1. Adobe RGB (1998) vs. Scanner. The red triangle represents the color gamut of Adobe RGB (1998) within the entire spectrum of visible (LAB) color. Adobe RGB encompasses most (but not quite all) of the color gamut of the Nikon 8000ED scanner, shown as the area bounded by blue. **Right**—Figure 2-2. Adobe RGB (1998) vs. Monitor. The color gamut of my Sony CRT monitor, bounded by the blue inner triangle, is compared to the larger gamut of Adobe RGB (1998).

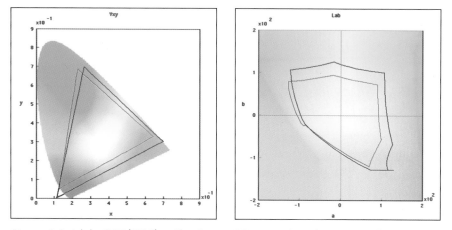

EACH COLOR MODE MUST HAVE A WORKING SPACE PROFILE ASSOCIATED WITH IT.

Figures 2-3. Adobe RGB (1998) vs. Ekta Space. CIE Yxy mode and CIE LAB mode. The gamut of Ekta Space (blue triangle) is broader than Adobe RGB (red triangle) for most colors. These figures represent two ways of presenting the same data. The figure on the left depicts CIE Yxy color information along x and y axes, whereas the figure on the right shows CIE LAB color data along *a* and *b* axes.

blue), and CMYK (cyan, magenta, yellow, black). Within Photoshop, color models are referred to as color modes.

In a color-managed workflow, each color mode must have a working space profile associated with it. Device-dependent color spaces are specific to a device and are seldom neutral or perceptually uniform, so the tones from black to white are not perceived as being evenly distributed. Consequently, after an image has been acquired from an input device, such as a digital camera or scanner, it should be converted to a device-independent color space, which represents a neutral, abstract color space defined by a white point, gamma, and red, green, and blue primaries. This conversion is performed using LAB mode, the only color space that is inherently device-independent—it conveys accurate color information without a profile.

In Photoshop, one can configure the working space to be any of the pre-defined, standard color spaces or any other device-independent color space for which a profile has been installed. I use Adobe RGB (1998) and Ekta Space, large color spaces that encompass the gamut (color range) of most RGB output devices, including scanners (fig. 2-1), monitors (fig. 2-2), and printers. Adobe RGB (1998) is recommended by many photographers for use in the digital darkroom due to its broad color gamut, and this is the color space into which I scan images from my Nikon scanner (Ekta Space is not an option). Adobe RGB is automatically installed (but not selected) as a color space during the installation of Photoshop on your computer.

An alternative color space, preferred by some photographers, is Ekta Space, a color space created by photographer Joseph Holmes to encompass the entire color gamut of Ektachrome films; it also includes most of the gamut of Velvia and other Fuji E-6 films. Ekta Space has a somewhat larger gamut than Adobe RGB (1998), with more blues and purples, but clips some E-6 yellows and dark greens that are rare in normal images (fig. 2-3). According to Holmes, only a very small bit (about 2%) of the most saturated darker cyans of a Fujichrome will be "smashed" inward to fit within this color space. Holmes explains, "The smashing of color that occurs when going from either of the Ektachrome or Fujichrome color spaces into any monitor profile, or even into a color space such as Adobe RGB (1998) or Bruce RGB is vastly greater…." This is the color space I choose for images scanned by commercial labs using drum scanners. The Ekta Space profile, available for download from www.profilecentral.com, must be manually added to your computer's color profiles folder.

COLOR MODELS

Color models specify the way in which a particular color is represented. The color model determines the number of colors that can be displayed in an image, in addition to the number of channels and the file size of an image.

HSB Model. The HSB model describes three basic characteristics of color:

COLOR MODELS SPECIFY THE WAY IN WHICH A PARTICULAR COLOR IS REPRESENTED.

- Hue represents the color reflected from or transmitted through an object. Measured as a location on the standard color wheel, it is expressed as a degree between 0° and 360°, with red defined by 0°.
- Saturation, or chroma, measures the strength of a color and represents the amount of the hue in proportion to gray, measured as a percentage from 0% (gray) to 100% (fully saturated). On the standard color wheel, saturation increases from 0 at the center to 100% at the periphery.
- Brightness is the lightness or darkness of the color, measured as a percentage from 0% (black) to 100% (white).

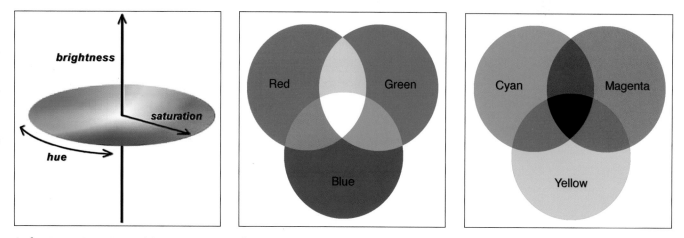

Left—Figure 2-4. HSB Model. Saturation varies from 0 at the center to 100% at the edge of the color wheel. Brightness varies from 0 to 100% along the vertical axis. Hue is measured in degrees around the circumference. Red = 0° or 360°, Yellow = 60°, Green = 120°, Cyan = 180°, Blue = 240°, and Magenta = 300°. **Center**—Figure 2-5. Additive colors (RGB): Red + blue + green create white; red + green produce yellow; blue + green produce cyan; red + blue produce magenta. **Right**—Figure 2-6. Subtractive colors (CMY): cyan + yellow produce green; yellow + magenta produce red; magenta + cyan produce blue.

Although the HSB model can be used in Photoshop to define a color in the Color palette or Color Picker, the HSB mode cannot be used to create or edit images.

RGB Model. Most of the visible spectrum can be created by mixing red, green, and blue (RGB) light in various amounts and intensities. Where these colors overlap, they produce cyan, magenta, yellow, and white. Because red, green, and blue combine to create white, they are called additive colors. Additive colors are used by scanners, digital cameras, color monitors, and our eyes.

Photoshop's RGB mode uses the RGB model, assigning a value to each pixel ranging from 0 (black) to 255 (white) for each of the RGB components in a color image. For example, the value of red is 255,0,0, which indicates that the color contains the maximum amount (255) of the red component and no green or blue components. If all components are 0, the result is black; when all components are 255, the result is white. When the values of all three components are equal, the result is a shade of neutral gray (which encompasses a range from black to white).

With 8-bit color depth, the maximum number of shades for each color is 256 (2^8). Combined, the three colors in RGB images contain 24 (8 x 3) bits of color information per pixel, reproducing up to 16.7 million colors (2^{24}). In 16-bit per channel images, this equates to 48 bits per pixel, or almost 300 trillion colors (2^{48})!

RGB is the default mode for new Photoshop images. Thus, even when working in color modes other than RGB, Photoshop temporarily uses the RGB mode to display images on-screen. This may be especially confusing when working with untagged images (those without an assigned profile).

Although RGB is a standard color model, the exact range of colors represented by the RGB mode varies depending upon the working space.

CMYK Model. The CMYK model is based on the absorption of light by inks printed on paper. As light strikes translucent inks, part of the spectrum is absorbed and part is reflected. When white light strikes yellow ink, the blue component of the light is absorbed, whereas the red and green components are reflected, combining to create yellow. Cyan absorbs red and reflects green and blue; it thus appears greenish blue. Magenta absorbs green and reflects red and blue.

Because pure cyan (C), magenta (M), and yellow (Y) pigments combine to absorb all color and produce black, they are termed subtractive colors. In actuality, impurities in all printing inks require that CMY be combined with black (K) ink to produce a true black. The subtractive colors are the colors formed by combining pairs of additive colors (RGB), and vice versa. Subtractive and additive colors are termed complementary colors. Red is complementary to cyan, green to magenta, and blue to yellow. Increasing or decreasing a color produces the opposite effect on its complementary color. Hence, decreasing cyan increases red, and so forth.

In Photoshop's CMYK mode, each pixel is assigned a percentage value from 0 to 100% for each of the inks. In CMYK images, pure white is generated when all four components have values of 0% and pure black when all components are 100%. The color red is expressed as 0,100,100,0, indicating that red is created by using the maximum values of magenta and yellow with no cyan or black ink.

CMYK mode is used when preparing an image to be reproduced using four-color process printing. Converting an RGB image into CMYK creates a color separation. However, for an RGB image, it is preferable to edit it first in RGB mode and then convert to CMYK. Note that we will not be dealing with CMYK mode when printing images with the LightJet or even CMYK inkjet printers, because these printers process images in RGB mode.

LAB Model. LAB color consists of a luminance or lightness component (L) and two chromatic components: the *a* component (from green to red) and the *b* component (from blue to yellow). These axes are based on the fact that a color cannot be both red and green or blue and yellow, since these colors oppose each other. In Photoshop, the *a* and *b* components are depicted as the abscissa (horizontal axis) and ordinate (vertical axis), respectively, on a plane of given luminance. Values for the *a* and *b* channels in the Photoshop Color Picker range from −128 to +127, and for the lightness channel from 0 to 100. In this mode, all color information is contained in the *a* and *b* components or channels; for neutral colors, $a = b = 0$.

LAB color is device-independent, producing consistent color without a profile regardless of the device (such as scanner, computer, monitor, or printer) used to create or output the image. In Photoshop, LAB color also serves as the intermediate mode between different color modes. Thus,

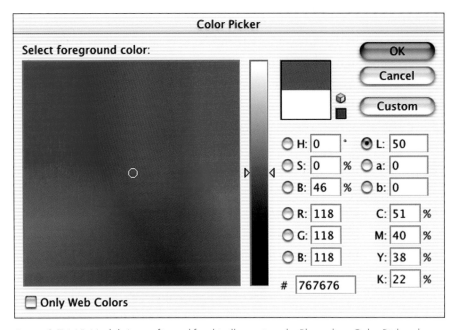

Figure 2-7. LAB Model. As configured for this illustration, the Photoshop Color Picker shows Lightness values along the vertical bar (where the L value 50 is selected) and, in the large square box, the range of the *a* component from green to red along the horizontal axis and the *b* component from blue to yellow along the vertical axis. Since *a* and *b* both equal 0, the color depicted is a neutral gray. Notice that with neutral colors, the saturation in HSB mode is 0, and the R, G, and B components in RGB mode are equal.

changing from RGB mode to CMYK mode involves an intermediate transition to LAB mode.

Grayscale Mode. Of importance to photographers producing black & white images from color originals, Grayscale mode displays up to 256 shades of gray in a single channel. To convert a color image to a grayscale image, Photoshop discards all the color information in the original image. Every pixel of a grayscale image has a brightness value ranging from 0 (black) to 255 (white), depending upon the luminosity of the original pixels. Grayscale values may also be recorded as a percentage of black ink coverage from 0 to 100%.

Although Grayscale is a standard color model, the exact range of grays represented varies depending upon the printing conditions. In Photoshop, Grayscale mode uses the range defined by the working space setting specified in Color Settings.

GRAYSCALE MODE DISPLAYS UP TO 256 SHADES OF GRAY IN A SINGLE CHANNEL.

PROFILES

In 1993, the International Color Consortium (ICC) was established by a group of companies, including Apple, Kodak, Adobe, and Microsoft, to encourage the standardization of open, cross-platform color management architecture and components for achieving consistent, predictable, and accurate color throughout digital workflows. The result was the development of ICC profile specifications used to create device profiles, which contain a table correlating device-specific RGB or CMYK colors to the actual

perceived color in XYZ or LAB mode. Each manufacturer of a digital camera, scanner, monitor, or printer provides a profile for that device. With these profiles, color data created on one device can be accurately translated into the color space of another device.

However, the profiles provided by manufacturers are not specific to a particular system and do not account for changes in devices that occur over time. Software products may be purchased to create customized profiles by measuring the color gamut and color response of individual devices.

It is especially important to calibrate and profile CRT monitors at the outset and periodically thereafter to compensate for changes in the phosphors as they age. Calibration refers to the process of setting a device to a known standard. In the case of a monitor, this means adjusting the contrast and brightness to their optimal settings and specifying a standard white point and gamma. Once your monitor has been calibrated, it must be profiled. Profiling is the process of characterizing a monitor's white point, gamma, and color behavior and saving those settings as an ICC profile. ICC-compliant applications, such as Photoshop, use the monitor profile to compensate for the differences between your working space and your monitor's color space, rendering the image correctly on-screen.

Various software and combination software/hardware options are available for calibrating and profiling monitors. For all of these products, I recommend setting the monitor gamma to 2.2, regardless of whether you are using a PC or Macintosh, since a gamma of 2.2 appears to be more perceptually uniform than 1.8.

I also recommend setting the monitor color temperature to D65, if available, or else 6500° K. This seems to represent a better choice than 5000° K (which looks very warm on-screen) for matching prints under D50 lighting or transparencies on a 5000° K light box. (Recall that higher color temperatures tend toward blue and lower color temperatures toward red, corresponding to the color emitted from a black box heated to that temperature. Do not confuse color temperature with wavelength.) Photoshop will automatically compensate for the difference between the white point of your monitor and working space.

Adobe Photoshop includes a utility called Adobe Gamma, which generates a monitor profile dependent upon visual feedback. Unfortunately, this lacks the accuracy necessary for the digital darkroom. As described previously under Digital Darkroom Equipment, I recommend a monitor calibration and profiling system that incorporates hardware with software, such as PhotoCal or OptiCal from ColorVision or Eye-One Monitor or Eye-One Display from GretagMacbeth.

An economical option is to utilize PhotoCal, which is sufficient for many photographers. However, it does require subjective user input to select the monitor brightness based upon the appearance of adjacent boxes of differing shades of gray. After launching PhotoCal, select Better for the quality

of calibration, gamma 2.2 and a monitor color temperature of 6500° K. In the subsequent dialogue box, choose the type of RGB controls available with your monitor. Individual RGB gun controls are preferred but are not essential. Then follow the remaining software instructions to generate your profile.

With OptiCal, set the white point of the monitor through the application called PreCal. Choose a target color temperature of D65 and follow the instructions to adjust the individual R, G, and B guns until the levels are inside the area defined in the dialogue box. Then launch OptiCal and set the Preferences to Monitor Spyder as the calibration sensor, Precision as the calibration mode, and Expert Controls with Maximum DeltaE 3.0, the default. From the main OptiCal dialogue box, choose your Selected Display, then enter a gamma of 2.2, and a monitor color temperature of D65. Check the OptiCal On option and click on the Calibrate button. In the subsequent dialogue box, Macintosh users should check the box to generate a ColorSync ICC Profile (rather than an Adobe Monitor Setup Profile). The associated software then displays a series of colors on the monitor as the colorimeter measures the monitor's output.

After creating a monitor profile with PhotoCal or OptiCal, the program will ask how you want to save the profile and if you want to make this your system profile. You may wish to incorporate the calibration program, white point, gamma, and date created in the profile name. If you are using only one monitor, or if this is the main monitor in a two-monitor system, click

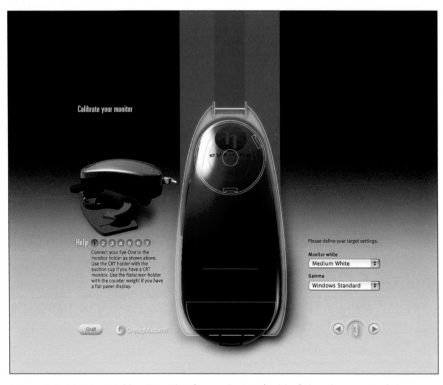

Figure 2-8. Monitor Calibration. This figure depicts (in blue) the placement of the spectrophotometer over an LCD monitor and the recommended monitor white and gamma settings.

INDIVIDUAL RGB GUN CONTROLS ARE PREFERRED BUT ARE NOT ESSENTIAL.

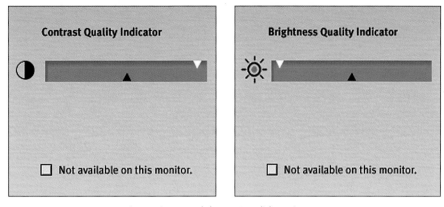

Figure 2-9. Eye-One Quality Indicators. (a) Contrast (b) Brightness.

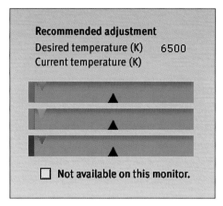

Figure 2-10. Eye-One Temperature Adjustment.

on the box to make this profile your system profile. With OptiCal and PhotoCal, you do not have the option to calibrate more than one system monitor, in contrast to the more expensive GretagMacbeth Eye-One Monitor.

The calibration procedure with the Eye-One Monitor, used in my darkroom, is similar. If you are calibrating a two-monitor system attached to a dual graphics card (i.e., a single graphics card with two monitor connectors), you may need to turn off the computer and disconnect the monitor you are not calibrating, then restart the system. After launching the Eye-One Match software, place the spectrophotometer in the calibration cradle. After calibration (which occurs automatically), attach the spectrophotometer to the monitor. A suction cup is supplied for CRT monitors but may damage LCD monitors, for which a counterbalanced strap supports the spectrophotometer. Select Medium White (which equals 6500° K) as the Monitor White and Windows Standard (which equals 2.2) as the Gamma (fig. 2-8).

Following the on-screen instructions, increase the contrast of the monitor to 100%. Wait for the contrast quality indicator to stabilize (fig. 2-9a), then proceed to the next screen. Minimize the monitor brightness, then increase it until the indicators align (fig. 2-9b). On the next screen, adjust the individual red, green, and blue color guns on the monitor until each color marker is aligned to the corresponding middle marker, thereby yielding a monitor white point of 6500° K (fig. 2-10). If your monitor does not allow adjustment of the individual color guns, or if you are calibrating an LCD monitor, check the box that indicates your monitor does not allow this adjustment, and proceed to the next step.

At this point, the brightness, contrast, gamma, and white point have been set. Now it is time to build the profile. Click on the next arrow and a

AT THIS POINT, THE BRIGHTNESS, CONTRAST, GAMMA, AND WHITE POINT HAVE BEEN SET.

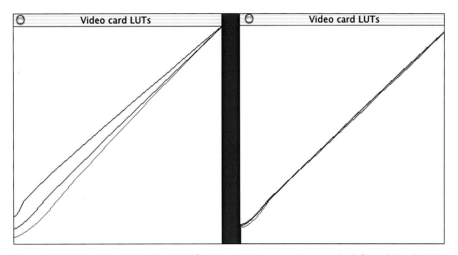

Figure 2-11. Video Card LUTs. The LUTs for Sony Trinitron monitor on the left and Apple LCD monitor on the right. Note the differential RGB gun output in the profile for the CRT monitor.

kaleidoscope of colors will flash before your eyes as the spectrophotometer measures your monitor's characteristics. When this step is complete, name this profile and save it as your monitor profile. It is recommended that you specify the monitor (if you are using more than one) and a date in the profile name. For example, I might call my profile Eye-1_Sony_Date. This profile incorporates a look-up table (LUT) that specifies the appropriate RGB output as a function of RGB input (fig. 2-11).

To create a custom profile for a scanner, a reference target is scanned. The associated software then compares the scanned data with a reference data file, evaluates the response of the scanner, and creates a custom profile for it. To create a printer profile, a test image supplied with the profiling product is printed from that printer, and that print is then scanned into the computer using the previously calibrated scanner. By analyzing these RGB values, the program generates a profile for the printer. I recommend first trying the manufacturers' profiles supplied with your scanner or printer. If the results are not satisfactory, you may search the Internet for alternative profiles (especially for printers) before you invest in a custom profile.

On Macintosh systems, ColorSync manages the profile information. On my Mac, profiles for color spaces and devices are located in Macintosh HD\System Folder\Application Support\Adobe\Color\Profiles\Recommended. In general, though, Mac OS 8–9 profiles are located in System Folder\ColorSync Profiles, whereas Mac OS X profiles are installed in Users*current user*\Library\ColorSync\Profiles. Your configuration may vary. If you are having trouble locating your Mac color profiles, search for adobergb (as in Adobe RGB). Mac users can view the active monitor profile from Control Panels>Monitors>Color or System Preferences>Displays>Color (fig. 2-12).

Windows color management utilizes ICM, which some have considered to be less sophisticated than ColorSync. An improved ICM has been incor-

TO CREATE A CUSTOM PROFILE FOR A SCANNER, A REFERENCE TARGET IS SCANNED.

porated into recent versions of the Windows operating system (but reportedly not NT). This updated version supports multiple color spaces, including sRGB, RGB, CMYK, and LAB, and multiple color management modules. In order to take advantage of these features, Windows users should be working in Windows 98 or later (but not NT). Windows users can check to see which profiles have been installed by looking in the folder C:\Windows\System\Color or, for Windows XP, C:\Windows\System32\Spool\Drivers\Color. To determine the default monitor profile, right click on the desktop, select Properties>Settings>Advanced>Color Management.

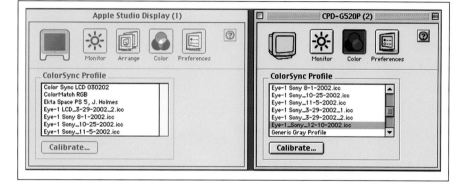

Figure 2-12. Monitor profiles (Mac). The box on the right, which is active, confirms that my Sony monitor is using the desired profile. Clicking the box on the left would reveal the profile used by my Apple LCD monitor.

COLOR MANAGEMENT MODULE

ICC color management utilizes a software engine called the color management module (CMM—also termed the color matching method or the "color engine") in conjunction with device profiles to match color across input, display, and output according to the render intent. Each image mode in Adobe Photoshop uses a color lookup table (LUT) to store the colors used in the image. The device profile instructs the CMM as to how to interpret color information.

Using LAB mode as a universal device-independent "language," the CMM translates the color information between devices and color modes so that the input from your scanner matches the output on your monitor and printer. For example, in order to display an image captured by a scanner on the monitor, the CMM retrieves the source profile from the scanner and the destination profile from the monitor. For each RGB value generated by the scanner, the CMM examines the source profile to determine the true color value in LAB mode. The CMM then evaluates the destination profile to find the monitor RGB value corresponding to that LAB value and converts the source RGB value to the destination RGB value. Analogous operations are applied for image conversions from the monitor to printer and from one color space to another. Thus, images can be displayed on any monitor or printed by any printer and maintain precise color, assuming accurate device profiles.

THE CMM TRANSLATES THE COLOR INFORMATION BETWEEN DEVICES AND COLOR MODES.

Within Photoshop, one can select the CMM and the render intent that specifies how color information is translated from one color space to another or to an output device. The CMM I recommend is Adobe (ACE), which uses the Adobe color management system and color engine (more on this on page 33). (Windows also offers the option of Microsoft ICM, and Macintosh offers several alternative engines.) The render intent I generally use is Perceptual. This algorithm compresses the total gamut from the source color space into the gamut of the destination color space when one or more colors in the original image is out of gamut in the destination color space, thereby preserving the perceptual relationship between the colors. An alternative render intent that may be appropriate for some images is termed Relative Colorimetric. With this intent, when a color in the current color space is out of gamut in the destination color space, it is mapped to the closest possible color within the gamut of the destination color space; colors that are within the gamut are not changed. However, this may cause "clipping," meaning that two colors that appear different in the source color space may appear the same in the target color space.

THIS ALGORITHM COMPRESSES THE TOTAL GAMUT FROM THE SOURCE COLOR SPACE.

3. Photoshop Essentials

Photoshop represents the premier image-editing program, offering a multitude of sophisticated techniques to process digital images. Several less expensive programs are also available, including Photoshop LE and Photoshop Elements. Some have suggested that Photoshop Elements may be sufficient for novices, but I feel that the lack of features such as Curves makes it unsatisfactory for high-quality image processing. Thus, the only product I recommend is the full version of Photoshop. If you are using Photoshop 5.5 or lower, I recommend that you upgrade to the latest version of Photoshop. If you are a PC user migrating to the Mac platform, special pricing is available for the cross platform Photoshop upgrade if purchased directly from Adobe.

IF YOU ARE USING PHOTOSHOP 5.5 OR LOWER, I RECOMMEND THAT YOU UPGRADE....

Within this section, I will discuss Photoshop features that are of particular interest or importance to photographers. The illustrations, derived from Photoshop operating under Mac OS, depict dialogue boxes that are virtually identical to those in Photoshop operating under Windows. The cloverleaf symbol in some menus refers to the Command (Cmd) key on the Mac and Control (Ctrl) key on the PC. In addition, the Option (Opt) key on the Mac almost always functions the same as the Alt key on the PC.

MENU BAR

The Menu bar, positioned horizontally across the top of the Photoshop window, contains menus for performing various types of tasks, of which the most important when getting started are Color Settings and Preferences.

Photoshop File Edit Image Layer Select Filter View Window Help Wed 7:22 PM

Figure 3-1. Menu Bar. Some versions do not show "Photoshop" at the left side of the menu.

Photoshop>Color Settings, or Edit>Color Settings. To specify Color Settings, select Photoshop>Color Settings or Edit>Color Settings. Adjust the settings as depicted in figure 3-2. The dialogue box displays my own custom settings entitled "mh," and I have placed a check mark in the Advanced Mode box to enable a choice of Conversion Options.

For Working Spaces RGB choose Adobe RGB (1998) if you will be working primarily with your own scans. Choose Ekta Space if you will be working primarily with images scanned into that color space. We are not concerned with the CMYK, Gray, or Spot settings for our image printing. If you are doing four-color process printing, you will want to obtain the appropriate settings from your printer.

For Color Management Policies, I recommend choosing Preserve Embedded Profiles. This will prevent you from inadvertently modifying the image by converting it to another color space when you open it. If you later wish to convert the image to a different color space, you can do so with the Image>Mode>Convert to Profile command, which offers a

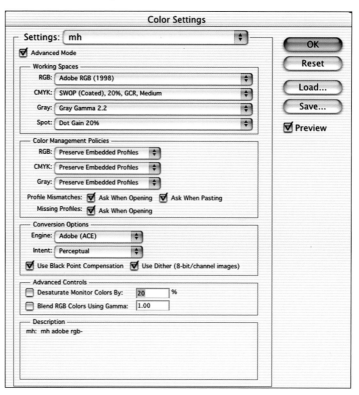

Figure 3-2. Color Settings. Choose Adobe RGB (1998) or Ekta Space as the RGB working space.

Preview of the appearance in the new color space before you make the conversion.

Check the Profile Mismatches and Missing Profiles boxes so you will be alerted to the mismatch and be able to decide how to handle it. However, I do not recommend assigning a different profile when opening a document, primarily because you are not afforded a preview of the change—only after the fact can you see what you did. For Conversion Options, choose Adobe (ACE) under Engine and Perceptual under Intent. Select Use Black Point Compensation (for Photoshop 6 and above) and Use Dither (to reduce banding artifacts when converting 8 bit/channel images between color spaces).

Ignore the Advanced Controls. Check the Preview box. When you have completed your selections, click on the Save button and specify a file name so you can reuse these settings. If desired, you can save different color settings for different types of projects.

Figure 3-3. General Preferences Dialogue Box. With limited memory, or if you do not plan to export the contents of the Clipboard to other applications, uncheck the Export Clipboard box.

Photoshop>Preferences>General, or Edit>Preferences>General. To select general preferences, choose Photoshop>Preferences>General or Edit>Preferences>General, or, better yet, press Cmd/Ctrl K. You will see a dialogue box, shown above with my recommended settings. Set the Color Picker to Adobe rather than Windows. Interpolation refers to the process of modifying pixels based upon adjacent pixels when a file size is increased (to produce a larger print) or decreased (to produce a smaller print). For optimal quality, the interpolation method should be set to Bicubic. Check the Dynamic Color Sliders box to change the slider colors in the Color palette as you move the sliders.

The other choices on this menu are primarily matters of personal preference and RAM. I use Cmd/Ctrl Z to undo and redo a given state and Cmd/Ctrl P to view the Print with Preview (rather than Print) dialogue box. The default number of History states is 20. If you have sufficient memory, I suggest increasing this number to 50 to facilitate reversing your steps; if your computer's RAM is challenged, you may need to decrease the number of history states to 10 or less.

Photoshop offers the option to export the clipboard from Photoshop. Since this may consume considerable memory, this feature should be selected only if you intend to paste the contents from the clipboard in Photoshop into another application. You can also choose to resize the image window when the magnification of the image is increased or decreased by using the keys Cmd/Ctrl and the plus key (+) or Cmd/Ctrl and the minus key (-[hyphen]). Check the option for Use Shift Key for Tool Switch in order to toggle between tools that are located under a single icon (e.g., the Lasso tool). With the box unchecked, you can use only the shortcut key (for instance, "L" for lasso) to select other similar tools.

FOR OPTIMAL QUALITY, THE INTERPOLATION METHOD SHOULD BE SET TO BICUBIC.

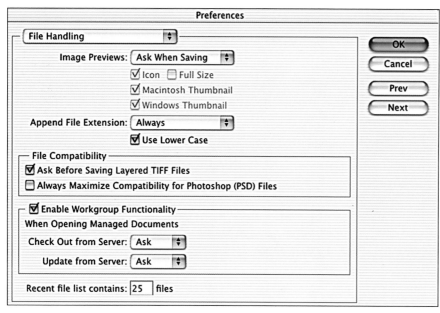

Left—Figure 3-4. Preferences for File Handling. Maximizing compatibility for Photoshop files adds an extra flattened composite layer. Workshop Functionality does not need to be checked unless you are sharing files in a collaborative setting. **Right**—Figure 3-5. Compatibility. There is no advantage to adding an additional flattened composite layer to the file.

Photoshop>Preferences>File Handling, or Edit>Preferences>File Handling. The Preference for saving files is called File Handling. The recommended settings are illustrated in figure 3-4. However, if you routinely save an icon and/or Macintosh or Windows thumbnail, you can specify to always include such a preview when a file is saved. Photoshop implies that if one does not check the Maximize Compatibility box, files may not be usable with subsequent versions of Photoshop. However, it appears that for image files, the only effect of checking the compatibility box is to add an additional flattened composite layer to the file (fig. 3-5). This seems to cre-

Figure 3-6. Preferences for Display & Cursors.

ate an unnecessarily large file, so I recommend leaving this box unchecked. Enabling Workgroup Functionality prevents more than one person in a collaborative endeavor from modifying a file at any given time. Showing at least ten files in the recent file list seems desirable to me.

Photoshop>Preferences>Display & Cursors, or Edit>Preferences> Display & Cursors. Since it is necessary to see the area affected by our brushes as accurately as possible, I suggest the cursor settings checked in figure 3-6, rather than the default settings. The resulting cursors, illustrated in the dialogue box on page 29, clearly reveal the areas affected by brushes and other tools with cursors. However, as indicated by the red brush stroke, some feathering will typically occur outside the region depicted by the cursor, depending upon the softness of the brush.

Figure 3-7. Transparency & Gamut. I generally use the default settings, but you may wish to experiment with different options.

Figure 3-8. Units & Rulers. Choose metric units for the rulers if desired. Choose from 240 to 360 pixels/inch as the default print resolution for new documents.

Figure 3-9. Guides, Grid & Slices. Modify the color and other features of guides, grid, and slices if desired. The default settings are illustrated.

Figure 3-10. Preferences for Plug-Ins & Scratch Disks. My operating system and Photoshop run from the Macintosh hard drive. To optimize scratch disk performance, I have designated a separate hard drive as the primary scratch disk.

Photoshop>Preferences>Plug-Ins & Scratch Disks, or Edit> Preferences>Plug-Ins & Scratch Disks. The Plug-Ins & Scratch Disks settings depicted in figure 3-10 are for a system with two hard drives. The Plug-Ins directory is dependent upon the location of your files but by default is within your Photoshop directory and is automatically recognized. If you maintain additional Plug-Ins in another directory, you can specify that location in this box.

Scratch disks represent virtual memory used by Photoshop when additional memory beyond RAM is required. If you have only one hard drive in your computer, specify that drive as the first scratch disk. However, if you have a second hard drive (preferably with at least 10GB of free space), specify that as your first scratch disk and your hard drive containing Photoshop and data as your second scratch disk (unless you have a third hard drive to serve in that capacity). Doing so will accelerate your system's performance.

SCRATCH DISKS REPRESENT VIRTUAL MEMORY USED BY PHOTOSHOP.

Figure 3-11. Memory & Image Cache. Specify maximal RAM percentage usage in this dialogue box. Mac OS9 and earlier users see text.

Photoshop>Preferences>Memory & Image Cache, or Edit>Preferences>Memory & Image Cache. Choose at least four cache levels in order to expedite viewing images at 66.7%, 50%, 33.3%, and 25% magnification (fig. 3-11). Each further increase in cache levels (up to eight) adds another decremental view (16.7% view at 5 levels with 12.5%, 8.3%, and 6.25% views, respectively, for each additional cache level). Do not use cache for histograms, which replaces real-time data with cached data for histograms of images not viewed at 100% (actual pixel) magnification.

Give Photoshop as much memory as you can, but save some for your operating system and other applications. This option is not available on this menu to users of Mac OS 9 and earlier. Instead, these users specify memory allocation by highlighting the Photoshop icon (not an alias) on the desktop, then selecting File>Get Info>Memory.

File>New. The command File>New will create a blank image based upon the same dimensions and resolution present in the clipboard or, if the clipboard does not contain image data, the last image you created. To base the image size on the last entered settings, hold down Opt/Alt when you select this command. To match the width and height of the new image to that of any open image, choose the name of the desired file from the listing of open images in the Window menu.

File>File Info. This tool allows you to add a variety of data to any image file, including captions, keywords, categories, credits, origin, copyright information, and a link URL, as depicted in figure 3-12. Photoshop images can also be annotated from the Toolbox.

CHOOSE AT LEAST FOUR CACHE LEVELS IN ORDER TO EXPEDITE VIEWING IMAGES. . . .

Figure 3-12. File Info. Append information for yourself or others.

Figure 3-13. Fade. Although a useful means of partially reversing or changing effects such as filters, this command cannot be applied to adjustment layers and thus cannot be modified after an image has been closed and the history states deleted.

Edit>Fade. A somewhat obscure though useful tool is the Fade command, which changes the opacity and blending mode of any filter, color adjustment, or painting or erasing tool applied to the image pixels. The effect of this command is similar to applying a filter on a separate layer and then using the layer opacity and blending mode to modify it. In essence, it functions as a "partial undo" option, made more powerful by the ability to specify a blending mode. To limit the amount of the previously applied action, decrease the opacity setting below 100%. Note that this command is available only immediately after applying the action.

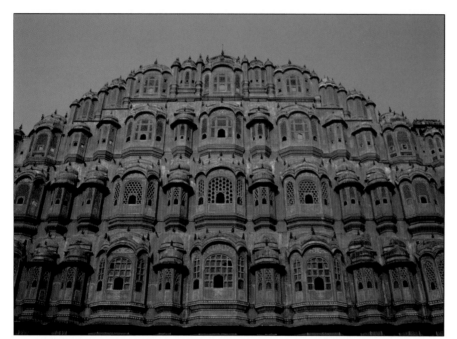

Top—Figure 3-14a. Original image shows convergence of vertical lines caused by tilting the camera upward without using a perspective control lens. **Bottom**—Figure 3-14b. By using the Transform>Perspective tool, the box bounding the image is distorted by dragging the upper corners outward and then moving the upper border upward to yield the effect of a perspective control lens.

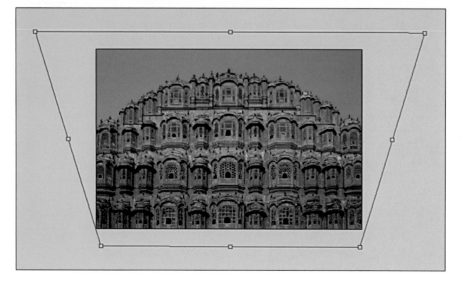

Edit>Transform>Perspective. This tool provides a method to correct for distortion introduced by not using a shift perspective control lens (fig. 3-14). An alternative means of adjusting perspective is to use the Crop tool and check the Perspective box that appears on the Options bar after making a selection.

Image>Mode. Use these tools under Mode to change the color mode of an image, to convert from an 8 bit to 16 bit/channel image, to assign a profile to an image file, or to convert an image from one profile to another (fig. 3-15). One should minimize the number of conversions from one color space to another, as some colors are inevitably and irretrievably lost with each conversion.

If you wish to change the color space of an image or tag an image with a printer profile, select the Convert to Profile option in the Mode menu. As depicted in figure 3-16, an image in LAB mode is being converted to the Adobe RGB (1998) color space. For all profile conversions, I recommend using the Adobe (ACE) engine, generally with perceptual intent, black point compensation, and dither. The advantage of using profile conversion, rather than assigning a profile, is that the conversion engine attempts to maintain the appearance of the image before and after the conversion, rather than simply assigning new color numbers to the old ones.

Top—Figure 3-15. Image Mode Menu. **Bottom**—Figure 3-16. Convert to Profile dialogue box. If the image has multiple layers, flatten it before conversion (make certain you keep a copy of the unflattened image in the original color space).

Top—Figure 3-17 (a). From the Levels dialogue box, click the Options box to access the auto color box. **Bottom**—Figure 3-17 (b). Auto Color Correction Options.

Image>Adjustments>Auto Color. Auto Color adjusts the color and contrast of an image to neutralize the midtones and clip the black & white pixels. In contrast to Auto Levels, Auto Color analyzes the image pixels (rather than the histograms of the channels) for similar shadows, midtones, and highlights.

To specify the manner in which auto color functions, open the Auto Color Correction Options dialogue box by clicking Options from either the Levels or Curves dialogue box (fig. 3-17a). The menu permits one to automatically adjust the overall tonal range, choose clipping percentages, and assign color values to shadows, midtones, and highlights.

Within this dialogue box are three algorithms:

- Enhance Monochromatic Contrast clips all channels to the same extent, maintaining the overall color relationship yet making shadows appear darker and highlights lighter. (Auto Contrast uses this algorithm.)
- Enhance Per Channel Contrast adjusts each channel individually to maximize tonal range, thereby creating a more dramatic correction but potentially introducing color casts. (Auto Levels uses this algorithm.)
- Find Dark & Light Colors uses the average lightest and darkest pixels in an image to maximize contrast while minimizing clipping. (Auto Color uses this algorithm.)

The Snap Neutral Midtones menu item adjusts midtone values in the image to convert an average nearly-neutral color into a true neutral color. Sometimes this improves the image, sometimes not.

Layer>New Adjustment Layer, and Layer>New Fill Layer. Adjustment layers represent layers added

Figure 3-18. New Adjustment Layer. This menu displays the techniques I routinely use when creating fine art prints, although I prefer to access them from the icons at the bottom of the layers palette (see below).

| Layer | Select | Filter | View | Window | Help |

New	▶	
Duplicate Layer...		
Delete	▶	
Layer Properties...		
Layer Style	▶	
New Fill Layer	▶	Solid Color...
New Adjustment Layer	▶	Gradient...
Change Layer Content	▶	Pattern...

Figure 3-19. New Fill Layer. This menu is grouped with the New Adjustment Layer menu on the Layers palette.

above image pixels that modulate the appearance of those pixels but do not change them. I use adjustment layers to apply Levels, Curves, Color Balance, Hue/Saturation, and Selective Color layers to my images (fig. 3-18).

Fill layers apply a solid color, gradient, or pattern in a separate layer overlying the pixels and, like adjustment layers, do not alter the underlying image pixels. This menu is also accessible from the new adjustment layer menu at the bottom of the Layers palette. These concepts will be explored in more detail in the following chapters.

Filter. Multiple filters are available within Photoshop—these include artistic effects, blur, noise, and sharpening tools. In addition, many third-party plug-ins are available and activated through this menu. I will discuss some of these filters later as I explain the application of specific techniques to my images.

Window>Documents>New Window. Use this command to view your document in a new window. (Use View>New View in Photoshop 6.) This action does not duplicate the image, but rather creates another view of the same image. One window can display the image at 100%, a channel, mask, or printer appearance while the other window shows the RGB or CMYK version, another printer appearance, and so forth.

Window>Workspace>Save Workspace. Photoshop users can save the location of their palettes—quite a time saver for those of us who prefer our own arrangement. One can even save distinct workspaces for different tasks or different users.

Window>File Browser or File>Browse. By default, the File Browser is located in the palette well. The browser allows users to view, sort, and process image files, showing thumbnails of the images in the folders selected (fig. 3-20). Operations such as creating new folders; renaming, moving,

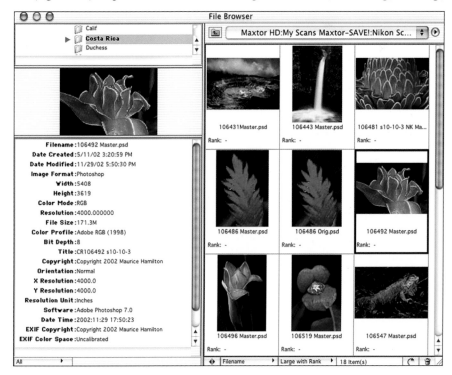

Figure 3-20. File Browser.

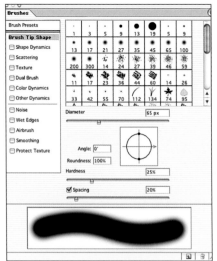

Figure 3-21. Brushes Palette.

Figure 3-22. Status Bar.

or deleting files; and rotating images can be performed from this convenient location. In addition, information on individual files and data imported from digital cameras can be viewed in this browser.

Window>Brushes. To display the Brushes palette, select the Brushes palette from the palette well (visible when your monitor resolution is at least 1024 pixels horizontally) or choose Window>Brushes. To adjust the size, shape, hardness, or spacing of the brushes, select Brush Tip Shape from the palette. Other options allow one to simulate different paper and canvas textures.

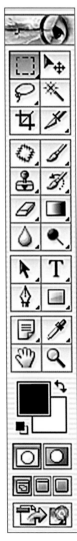

Window>Show Status Bar. You can use the show status information feature to view important document data. PC users should display the status bar with the Window>Show Status Bar command. For Macintosh users, the status information is automatically displayed at the bottom of each open image (fig. 3-22). When Document Sizes is selected, the number on the left represents the approximate size of the flattened file in Photoshop PSD format, whereas the number on the right indicates the file's approximate size with layers and channels. For Scratch Sizes, the number on the left represents the total amount of memory currently being used by Photoshop, and the number on the right is a fixed number that represents the total amount of RAM available for processing images. If the Efficiency value is less than 100%, Photoshop is using the scratch disk, thereby operating more slowly.

USE THE SHOW STATUS INFORMATION FEATURE TO VIEW IMPORTANT DOCUMENT DATA.

TOOLBOX

The Toolbox, that collection of icons positioned by default along the left-hand side of the Photoshop work area, includes both selection and painting tools (fig. 3-23). The Options bar at the top of the work area allows one to select the options available for the selected tool. If an option is grayed-out, it is not available for use on your current layer—this

Figure 3-23. Toolbox icons.

often occurs when an image layer has not been selected in the Layers palette.

To most efficiently switch between these tools, some—if not all—of the toolbox shortcuts listed in the chart on the right should be memorized.

Selections. Selections represent a powerful tool for limiting changes to specific areas within an image. Once a selection has been made, only the selected area will be affected by adjustments or other changes to the active layer. Tools used for making selections include the Marquee, Lasso, and Magic Wand.

Marquee Tool (M). This selection tool creates rectangular or elliptical shapes (which can be combined or subtracted from each other) in addition to selections of a single row of pixels along a horizontal or vertical axis (which may be useful for removing stray pixels along the edge of an image). The Marquee Options bar offers additional choices that are self-explanatory.

SHORTCUT KEYS	
M	Marquee Tool
V	Move Tool
L	Lasso Tool
W	Magic Wand Tool
C	Crop Tool
B	Paintbrush Tool
S	Clone Stamp Tool (formerly Rubber Stamp)
J	Healing Brush Tool and Patch Tool
Y	History Brush Tool
E	Eraser Tool
G	Gradient Tool and Paint Bucket Tool
I	Eyedropper Tool and Measure Tool
H	Hand Tool
Z	Zoom Tool
D	Default Foreground and Background Colors
X	Exchange Foreground and Background Colors
Q	Quick Mask Mode (Enter or Exit)
F	Switch Screen Modes

SELECTIONS REPRESENT A POWERFUL TOOL FOR LIMITING CHANGES TO SPECIFIC AREAS.

If you press the Shift key as you create a rectangular or elliptical selection, the shape will be constrained to a square or circle, respectively. (However, if another selection is present, pressing the Shift key instead adds to that selection.) Pressing the Opt/Alt key causes the selection to be drawn from the center outward, i.e., it is centered at the origin of the click. (If another selection is present, this command instead subtracts the new selection from the existing selection.) Pressing the Spacebar while using the rectangular or elliptical Marquee tool allows one to reposition a selection as it is being created. While dragging over an image to create a selection,

Top—Figure 3-24. Marquee Menu. **Bottom**—Figure 3-25. Marquee Options Bar. The four boxes to the right of the Marquee tool icon specify options to create a new selection, add to an existing selection, subtract from a selection, or choose overlapping areas of selections.

press the Spacebar to move the selection (keeping the mouse button depressed), then release the Spacebar to modify the selection, repeating this sequence until the proportions and position of the selection have been optimized.

Figure 3-26. Lasso Tool Menu.

Lasso Tool (L). One of the most versatile selection tools is the Lasso. Using the standard Lasso tool, one can make a closed freehand selection. This works well for broad selections, which can then be feathered (Select>Feather). For a selection along straight lines, try the Polygonal Lasso. For a selection along an edge with high contrast, try the Magnetic Lasso.

Figure 3-27. Lasso Tool Options Bar.

Magic Wand Tool (W). This tool creates a selection based upon the similarity of a color to the image pixels clicked and is used to select an area with the same or similar color, such as a flower or the sky. Set a tolerance in the Options bar to specify the range of colors that will be selected (fig. 3-28). Start with a tolerance of 8 for areas clearly separated from adjacent areas. If this does not include the desired areas, double the tolerance and select again. The Options bar also includes a choice between selecting contiguous pixels or pixels anywhere in the image within the tolerance range specified, in addition to modes for adding to or subtracting from the selection. Color Range (see below) represents a similar, but more versatile, tool. The tolerance setting in the Magic Wand tool also determines the tolerance used for the Select>Grow and Select>Similar commands in the Menu bar.

Figure 3-28. Magic Wand Options Bar.

Several techniques for modifying selections apply to these tools. Clicking inside a selection allows one to drag the selection without moving the image pixels. To move image pixels, depress the Cmd/Ctrl key to temporarily change the cursor into the Move tool. A selection may be feathered (the margins made softer) by choosing Select>Feather and specifying the radius of the feather. Since this feathering is applied to each side of the selection, a feather of 5 pixels, for example, produces feathering of 5 pixels on each side of the selection, for a total of 10 pixels. I generally do not check the feather box on the Options bar, since this causes that feather to be applied the next time I use the tool, potentially without my realizing it.

Useful selection commands include the following:

- Cmd/Ctrl click on a layer mask thumbnail or channel. Loads the layer mask or channel as a selection. (Layer masks are described on pages 50–51.)

- View>Show Extras, or Cmd/Ctrl H. Hides the selection so the "marching ants" do not distract you even though the selection remains active.
- Select>Modify>Border. Modifies a selection to include only the specified width along the border of the selection.
- Select>Modify>Smooth. Smooths jagged edges on the selection.
- Select>Modify>Expand. Increases the size of the selection by the number of pixels specified.
- Select>Modify>Contract. Decreases the size of the selection by the amount specified.
- Select>Grow. Adds all adjacent pixels that match the tolerance setting in the Magic Wand tool.
- Select>Similar. Adds to the selection, based upon the tolerance setting in the Magic Wand tool.
- Select>Inverse. Inverts a selection—the unselected becomes selected.
- Select>Reselect. Reloads the last selection.
- Select>Save Selection. Saves an active selection as a channel so it can be reloaded using the Select>Load Selection command.

Paintbrush, Pencil, and Airbrush Tools (B). The Paintbrush, my favorite drawing tool, applies the foreground color to an image. When painting on a mask, it applies black or white (or intermediate shades of gray). As with other drawing tools, holding the Shift key while clicking with the cursor paints a straight line between the selected points.

After selecting the Paintbrush icon (or pressing B), choose a soft or hard brush of the desired size from the Options bar or Brushes palette. To vary the size of the brush, press the bracket keys, the left open bracket symbol ([) to make the brush smaller or the right close bracket symbol (]) to make it larger. To create a medium hardness brush, select Brushes palette>Brush Tip Shape and choose the desired hardness. Hardness values of 65–80% are often useful. Brush spacing determines the spacing between the brush marks in a stroke; a smaller number yields a smoother stroke. I often set the brush spacing to 20%, rather than the default value of 25%.

BRUSH SPACING DETERMINES THE SPACING BETWEEN THE BRUSH MARKS IN A STROKE.

Figure 3-29. Paintbrush Options Bar. Clicking the icon at the far right of the Options bar displays the Brushes palette.

The Mode of the brush is usually set to Normal, but other options may be selected to apply different blending modes to the painted pixels. The opacity of the brush is specified in the Options bar. Flow determines how rapidly the Paintbrush applies ink, thereby affecting both the density and diffusion of the paint. With flow settings less than 100%, multiple applica-

tions are necessary to achieve the specified opacity. If flow is set to 100%, the Paintbrush paints with the specified brush opacity as long as the mouse button is not released. If the mouse button is released and pressed again, the Paintbrush again applies that same brush opacity to the strokes (up to 100% opacity).

The Pencil tool resides with the Paintbrush and functions similarly but uses only hard-edged brushes—I seldom use this tool. The Airbrush tool is accessed by clicking its icon (located to the right of the flow setting) on the Paintbrush Options bar. This tool applies hard or soft strokes of varying opacity (called "Pressure" in the Options bar). In contrast to the Paintbrush, the opacity and diffusion of the stroke from the Airbrush increase as long as the mouse button is depressed (up to 100% opacity).

THE ERASER TOOL ERASES TO TRANSPARENCY ON ALL LAYERS EXCEPT THE BACKGROUND LAYER.

Eraser, Background Eraser, and Magic Eraser Tools (E). The Eraser tool erases to transparency on all layers except the Background layer—on which it paints with the background color. The Eraser mode can be set to Paintbrush, Pencil, Airbrush, or Block (like the old square eraser). By checking the Erase to History box on the Options bar, one can erase back to a particular level in the History palette—performing the same operation as using the History Brush tool.

Figure 3-30. Eraser Options Bar. Like the Paintbrush Options bar, the Eraser Options bar offers settings for blending mode, opacity, flow, and the Airbrush.

The Background Eraser tool erases pixels in the brush area if they match the color of the pixel in the center of the brush. The tolerance setting determines the color range of pixels erased. The Discontiguous Limits setting removes all pixels within the brush area if they match the sampled color, whereas Contiguous erases pixels only if they are also connected to each other. The Find Edges Limits option is similar to Contiguous but preserves edge sharpness better. The Sampling mode specifies whether the color is sampled only with the first click or continuously as you drag through the image.

Top—Figure 3-31. Background Eraser Options Bar. **Bottom**—Figure 3-32. Magic Eraser Options Bar.

The Magic Eraser functions similarly to the Background Eraser, except the entire image is affected. Its function is somewhat the opposite of the Paint Bucket, since it erases instead of paints. As with the Background eraser, one sets a tolerance and may choose between Contiguous or Discontiguous pixel removal. Anti-aliased smooths the edges when erasing. Other options include the opacity setting and the choice between erasing only the currently selected layer or all layers in the image.

History Brush Tool (Y). The History Brush represents one of the most powerful tools in Photoshop and allows you to paint back to any prior state listed in the History palette. To use it, select the History Brush icon in the Toolbox, then click the box to the left of the History palette state to which you wish to return—the History Brush icon appears at that level. The Options bar appears identical to the Paintbrush Options bar, aside from the icon indicating the selected tool. Now paint on your image to transform those pixels back to the selected state, as illustrated in figure 3-33.

Clone Stamp Tool (S). This tool samples a portion of the image, selected by Opt/Alt clicking on the source, and applies it to another part of the same image or another image. I usually check the Aligned box, which changes the sampling point (indicated by a target if you selected Other Cursors: Precise in Display &

Figure 3-33. History Palette and History Brush Tool. As the History palette indicates, the file was opened and duplicated onto a separate layer. The name of the layer was changed to "blur," which represents a change in Layer Properties, and a Gaussian Blur was applied to the duplicate layer. Next, the History Brush was selected, and the box to the left of Layer Properties (representing the image before blurring) was checked so the History Brush will paint pixels from this sharp layer onto the current layer (which is blurred).

Cursor Preferences) as the cursor is moved (fig. 3-34). As with the paint tools, the size and hardness of the brush need to be specified. The hardness of the brushes in your palette should include hard, medium (65–80% hardness), and soft. To repair defects on an image, I usually clone using a soft or medium brush at 100% opacity. For blending, one may clone using a lower opacity, such as 60–70%, or even around 20% for a subtle effect.

I USUALLY CLONE USING A SOFT OR MEDIUM BRUSH AT 100% OPACITY.

Figure 3-34. Clone Stamp Options Bar.

If you do not obtain the expected results, verify that the layer to which you want to apply these effects is highlighted and that the Clone Stamp tool mode is set to Normal and the opacity to 100% (unless you want to blend pixels).

Healing Brush Tool and Patch Tool (J). The Healing Brush allows one to erase imperfections and blend them into the surrounding image. It evaluates the area selected for retouching and then modifies it to blend with the surrounding image—a "smart" Clone Stamp. Though similar in concept to the Clone Stamp tool, the Healing Brush is designed to preserve the texture, lighting, and shading in the retouched area. Moreover, in con-

trast to the Clone Stamp tool, the Healing Brush can only paint on a layer containing pixels.

To use the Healing Brush, select the bandage icon from the Toolbox. Choose Sampled as the Source in the Options bar to select pixels from the image (fig. 3-35). Select Aligned in the options bar to continuously apply the sampled pixels, or deselect Aligned to sample only from the initial sampling point. To preserve noise and texture at the edges of the brush stroke, choose the Replace blending option from the Mode pop-up menu in the Options bar. Opt/Alt click to choose the sampling point. Then drag over the image area to be healed; each time the mouse button is released, the sampled pixels are blended with the existing pixels. If strong contrast (such as a dark area) is present at the edges of the area to be healed, make a selection larger than the area you want to heal but exactly along the boundary of the contrasting pixels, then apply the Healing Brush to the selection.

TO USE THE HEALING BRUSH, SELECT THE BANDAGE ICON FROM THE TOOLBOX.

Figure 3-35. Healing Brush Options Bar. Adobe issues the only license you need to heal in Photoshop.

The Patch tool is coupled with the Healing Brush in the Toolbox. This tool allows one to repair a selected area with pixels from another area, matching the color, brightness, and texture of the sampled pixels to the repaired area. For best results, select a small area when patching.

Selecting the Patch tool changes the cursor into a "Lasso." Drag this cursor in the image to select the area to be repaired (or choose any other selection tool to define the area) and choose Patch: Source in the Options bar (fig. 3-36). Adjust the selection if necessary to encompass the desired area. Place the cursor inside the selection and drag it to the area to be sampled. Alternatively, you can select Destination in the Options bar, select an area to be sampled, and drag the selection to the area to be repaired.

Figure 3-36. Patch Tool Options Bar. With Source selected, use the Lasso tool to select the problem area and drag it to the area to be sampled.

Gradient and Paint Bucket Tools (G). The Gradient tool creates a blend between two or more colors. Select a gradient from the Gradient picker (click the triangle to the right of the gradient sample in the Options bar), then choose the type of gradient, such as linear or radial, from the

Figure 3-37. Gradient Options Bar. The gradient depicted is foreground to background (with black foreground and white background). The set of five boxes specifies the type of gradient; I usually use linear (as in this figure) or radial (the gradient adjacent to linear). With the selected gradient, checking the Reverse box will yield a background to foreground gradient.

Options bar (fig. 3-37). Other gradient options include reversing the order of the colors in the gradient and dithering to create a smoother blend with less banding.

To access the Gradient Editor, click on the gradient sample in the Options bar. As shown in figure 3-38, this reveals a dialogue box that permits customization of the gradient, including colors and opacity. This feature is likely to be more use-

Figure 3-38. Gradient Editor.

ful for graphics artists than photographers, but I do sometimes modify the stops for the foreground to background gradient when burning the edges of an image.

To create the gradient, position the cursor in the image at the desired starting point and drag to the ending point. The longer the line, the more gradual the blend. I most often use this tool to apply gradients for blending in layer masks.

The Paint Bucket tool fills areas similar in color to the pixels selected using the cursor with the foreground color. For photographers, its main value may be to identify the location of the Gradient tool on the Toolbox.

Blur, Sharpen, and Smudge Tools (R). I do not use these tools very often, but they may be useful to modify small regions within the image. For example, the Sharpen tool can be used to enhance specular highlights. The Blur tool can be used to soften small areas within an image. As with the Airbrush, the longer one brushes over an area with these tools, the greater the effect.

Dodge, Burn, and Sponge Tools (O). I mention the Dodge and Burn tools primarily to discourage their use—they apply linear changes to the brightness and contrast of an image and are inferior to the nonlinear changes available with Levels and Curves, as described below.

The Sponge tool may occasionally be useful to increase or decrease the saturation over a portion of the image.

Eyedropper, Color Sampler, and Measure Tools (I). The Eyedropper tool allows one to select and set any color from an image to the foreground color and use that color with any drawing tool. Used in conjunction with the Info palette, it allows one to simultaneously measure color values at any point on an image in two of the standard color modes (I usually use RGB and LAB). To access the Eyedropper tool while using a brush, press the Opt/Alt key.

THE SHARPEN TOOL CAN BE USED TO ENHANCE SPECULAR HIGHLIGHTS.

Figure 3-39. Eyedropper Options Bar. Choose a sample size of either 3 by 3, or 5 by 5 pixels.

The following is the Info Palette table:

R :	162		L :		45
G :	66		a :		49
B :	0		b :		59
X :	0.586		W :		
Y :	0.987		H :		
#1 R :	231		#2 R :		209
G :	175		G :		101
B :	0		B :		0
#3 R :	36				
G :	19				
B :	11				

Left—Figure 3-40. With the Color Sampler selected, I clicked on three areas of this image, which are numbered sequentially. **Right**—Figure 3-41. Info Palette. The RGB and LAB values at the top of the box refer to the color under the cursor, whereas the RGB values at the bottom of the palette correspond to the color values sampled in the previous figure.

The Color Sampler tool is used to sample color data from fixed locations on the image. Click on up to four areas of your image that you want to sample (fig. 3-40). The Info palette (fig. 3-41) shows information for the selected pixels in the specified color space (which can be changed by clicking on the Eyedropper icon adjacent to pixel values in the Info palette). Now, while making adjustments to your image in Levels or Curves, you can monitor changes in the color values at those selected points. This may be used to make highlights, midtones, or shadows within the image neutral by adjusting Levels or Curves until the RGB values are equal. Following such adjustments, both before and after color values for the sampled pixels are depicted in the Info palette.

Foreground and Background Colors. The foreground and background colors are depicted by the two boxes (black & white by default) near the bottom of the Toolbox. Press D to return to the default black foreground and white background colors (or white foreground and black back-

ground if you are working on an adjustment layer or layer mask). Press X to exchange the foreground and background colors. Clicking on the foreground or background color swatch opens the Color Picker.

Color Picker. To access this option, click on the foreground or background color in the Toolbox or the Color palette. To select a new foreground or background color, click on that color in the Color Picker dialogue box or enter the values for HSB (hue, saturation, brightness) color, RGB (red, green, blue) color, LAB (Lightness, *a* channel, *b* channel) color, or CMYK (cyan, magenta, yellow, black) color.

By default, the Color Picker shows HSB colors, and the radio button by Hue is marked. With this configuration, Hue is displayed in the vertical bar to the left of the buttons and is adjusted by moving the slider up or down. The square box to the left shows the Saturation, ranging from 0 at the left to 100% at the right, and Brightness, ranging from 0 at the bottom to 100% at the top. Figure 3-42 depicts HSB colors for a saturated red containing a little blue. The subsequent figures show the Color Picker for the same color, depicted in RGB (fig. 3-43) and LAB (fig. 3-44) color spaces.

Left—Figure 3-42. Color Picker, HSB. The vertical bar shows the Hue. In the square box, Saturation is shown along the horizontal axis and Brightness along the vertical axis. Selecting the Saturation or Brightness radio button displays that component in the vertical bar and the remaining two components in the square box. **Center**—Figure 3-43. Color Picker, RGB. For the same color as in figure 3-42, this figure depicts Red in the vertical bar and, in the square box, Blue (along the horizontal axis), and Green (along the vertical axis, but absent from the selected color). **Right**—Figure 3-44. Color Picker, LAB. Also for the same color as in the previous two figures, the Lightness is shown in the vertical bar and, in the square box, the a component (from green to red along the horizontal axis) and the b component (from blue to yellow along the vertical axis). The 0 values for a and b are at the center of the box, with positive and negative values that encompass the visible spectrum as discussed in the previous chapter.

Quick Mask Mode (Q). This mode changes an existing selection to a mask or, if no selection is active, creates a mask that can be modified by the painting tools. As with all masks, painting with white adds to the selection (decreasing the mask) and painting with black subtracts from it. Although this represents a convenient way to modify a selection, a disadvantage of using Quick Mask is that the mask is not automatically saved. To save the mask, go to the Channels palette and drag the Quick Mask layer to the Create New Channel icon at the bottom of the palette. Or, return to Standard mode, which will now display the area as a selection, and either choose Select>Save Selection from the Menu bar or click the Save Selection as Channel icon at the bottom of the Channels palette.

Palette Layout. I advocate using a separate monitor to display the work area, including the palettes. My own preferred layout is depicted in figure 3-45, which shows separate columns for Layers, Channels, History, and Navigator/Info/Color/Actions. I highly recommend that you save the location of these palettes (Window>Workspace>Save Workspace).

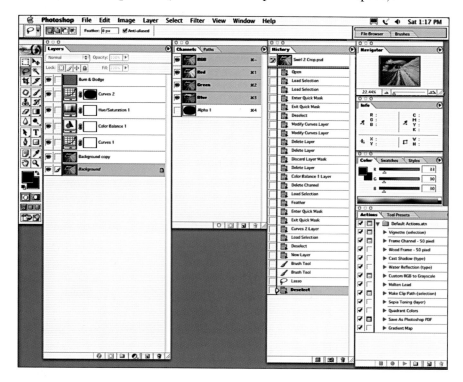

Figure 3-45. The Palette Layout. Layers, Channels, History, Navigator, Info, Color, and Actions palettes are visible with this layout.

Navigator Palette. The Navigator palette provides a convenient way to move around an image: simply drag the red box (which represents the portion of the image visible on the monitor) with your mouse (fig. 3-46). The Navigator is also helpful when viewing or editing pixels in an image, since it allows you to confirm your position within the image.

Figure 3-46. Navigator Palette. The image may be changed to a specific magnification by specifying the desired number in the percentage box on the left. Alternatively, the magnification can be decreased by clicking the small mountain icon on the left of the slider bar or increased by clicking the larger mountain icon on the right.

Color Palette. In addition to showing the foreground and background colors, the Color palette displays sliders for the color values in the desired color mode (including RGB, shown in figure 3-47, HSB, LAB, and CMYK). One can change the foreground or background color by selecting the appropriate box and moving the color sliders or sampling a color from an image or the color ramp at the bottom of the box.

Layers Palette. Layers represent the key to the power of Photoshop. Each layer in an image constitutes a

separately editable component of the image that overlies and modifies those layers below it (fig. 3-48). When a new layer is created, it is positioned immediately above the highlighted layer. However, the position of a layer can be changed by dragging it up or down.

Figure 3-47. Color Palette. The foreground and background colors were selected from the adjacent image. The exclamation mark in the triangle indicates that the color in the adjacent box is out of gamut for CMYK printing.

Adjustment Layers. Whenever possible, use adjustment layers (Layer> New Adjustment Layer, or click on the icon at the bottom of the Layers palette) rather than image adjustments(Image>Adjustments) to edit an image, since adjustment layers do not change the image pixels. In addition, adjustment layers can be modified anytime, as long as layers are saved with the image.

Most of my image processing occurs via adjustment layers. The adjustment layer properties I use most commonly are Levels, Curves, Color Balance, Hue/Saturation, and Selective Color (fig. 3-49). Familiarity with the creation of these adjustment layers is assumed in the following chapter, which makes extensive use of adjustment layers during creation of the master image file.

THE OPACITY OF EACH LAYER CAN BE INDEPENDENTLY ADJUSTED.

Layer Opacity. The opacity of each layer can be independently adjusted. This is especially useful when applying a filter or other special effect to a duplicate layer. By reducing the opacity of the duplicate layer, the normal layer below is revealed, merging the effect with the original image.

Fill Opacity. The fill opacity affects pixels painted on a layer but, unlike the layer opacity, does not change the opacity of layer styles or blending modes. Fill opacity can be selected from either the Fill Opacity box in the Layers palette or Layer>Layer Style>Blending Options.

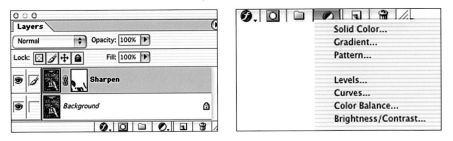

Left—Figure 3-48. Layers Palette. Normal blending mode, 100% opacity, and 100% fill opacity applied to the Sharpen layer. The icons running from left to right at the bottom of the Layers palette permit one to add a layer style, add a layer mask, create a new layer set into which layers can be organized, create a new fill or adjustment layer, create a new layer, and delete a layer, respectively. **Right**—Figure 3-49. New Adjustment Layer Menu. Click the half black/half white circular icon at the bottom of the Layers palette to access this menu. Opt/Alt clicking on the icon allows one to specify a layer name, mode, and opacity when the layer is created.

Blending Modes. A blending mode can be selected for each layer, determining the manner in which it interacts with the layer below (the base). The result is a new appearance dependent upon the combination of the two layers. The default blending mode is Normal, indicating that no blending occurs. The blending mode menu, accessed by clicking on the box at the upper left of the Layers palette, is depicted in figure 3-50.

The blending modes photographers are most likely to use include the following:

- *Multiply* multiplies the base color by the blend color to produce an effect similar to superimposing transparencies. This mode always darkens the colors, except that black & white remain unchanged.
- *Screen* multiplies the inverse of the base and blend colors, producing an effect similar to projecting transparencies on top of each other. The effect is to lighten colors, except that black & white are not changed.
- *Darken* selects the darker of the base or blend colors. Base pixels lighter than the blend color are replaced, and pixels darker than the blend color are unchanged.
- *Lighten* selects the lighter of the base or blend colors. Base pixels darker than the blend color are replaced, and pixels lighter than the blend color are unchanged.
- *Soft Light* lightens or darkens colors, depending upon whether the blend color is lighter or darker than 50% gray, respectively.
- *Overlay* multiplies or screens colors, depending on the base color. The blend color overlays the base color while preserving the base color's highlights and shadows to preserve the lightness or darkness of the original color.
- *Color Burn* darkens the base color to reflect the blend color. Blending with white produces no change.
- *Color Dodge* brightens the base color to reflect the blend color. Blending with black produces no change.
- *Hard Light* multiplies or screens the colors, depending on the blend color. If the blend color (light source) is lighter than 50% gray, the image is lightened, as if it were screened. If the blend color is darker than 50% gray, the image is darkened, as if it were multiplied. The effect has been compared to shining a spotlight on the image and tends to be harsh.
- *Vivid Light* burns or dodges the colors by increasing or decreasing the contrast, depending upon the blend color. If the blend color is lighter than 50% gray, the image is lightened by decreasing the contrast. If the blend color is darker than 50% gray, the image is darkened by increasing the contrast.

Figure 3-50. Layers Blending Modes. Multiply produces an effect like sandwiching two slides together. Screen produces an effect like projecting one slide on top of another.

- To create a new layer, hold the Opt/Alt key and click on the New Layer button at the bottom of the Layers palette—this permits you to name the layer.

- To duplicate a Layer, right click on it and select Duplicate Layer, or drag the layer to the New Layer button at the bottom of the Layers palette, holding the Opt/Alt key to specify a name for the layer. Alternatively, select the Move tool and hold the Opt/Alt key as you drag in the image.

- To change the name of a layer, double click on the layer name. (Opt/Alt double click on the layer to change the name in Photoshop 6 and earlier.)

- To hide a layer, click on the eye icon to the left of the thumbnail icon. Hidden layers cannot be edited. Click the box again to show the layer, and the eye icon reappears.

- To inactivate/reactivate a layer mask, Shift click on the layer mask icon.

- To reveal layer styles, double click on the layer or click on the add a new layer style button at the bottom of the Layers palette.

- To copy a selection into a new layer, select Layer>New>Layer Via Copy—or better yet, click Cmd/Ctrl J.

- To link layers, select one and then click the box to the left of the thumbnail for each layer to be linked. A chain icon will appear in the box of each layer linked to the selected layer.

- To unlink all layers, hold the Opt/Alt key and click on the Paintbrush icon for the layer to which the other layers are linked.

- To center an image when dragging a layer from one image to another, hold the Shift key. This technique is especially helpful to align images of the same pixel dimensions.

- To prevent pixels from being accidentally repositioned or modified, lock transparent or image pixels, the position, or both of these. If a layer is not behaving as expected, make sure it is not locked.

- To limit the effect of one or more new layers to a single layer, group them with that layer to form a clipping group. To accomplish this, highlight the target layer, press Opt/Alt, and click the Create New Fill or Adjustment Layer icon at the bottom of the Layers palette. In the dialogue box, name this layer and check the box labeled Group with Previous Layer. The new layer will appear indented above the previous layer (termed the base layer) with an arrow pointing down toward that layer. If the layers to be grouped have already been created, position the layer producing the effect above the target layer and Opt/Alt click the interface between the layers to link them as a clipping group.

IF A LAYER IS NOT BEHAVING AS EXPECTED, MAKE SURE IT IS NOT LOCKED.

- *Hue* creates a result color with the hue of the blend color and the luminance and saturation of the base color.
- *Saturation* creates a result color with the saturation of the blend color and the luminance and hue of the base color.
- *Color* creates a result color with the hue and saturation of the blend color and the luminance of the base color. This maintains the gray levels in the image and can be used to tint color images.
- *Luminosity* creates a result color with the luminosity of the blend color and the hue and saturation of the base color.

Layer Styles. Layer styles are composed of one or more layer effects and can be applied to any layer in an image. I find them useful for text or frames. Layer styles include the following effects:

- *Drop Shadow* adds a shadow that falls behind the contents on the layer.
- *Inner Shadow* adds a shadow that falls just inside the edges of the layer contents, giving the layer a recessed appearance.
- *Outer Glow* and *Inner Glow* add glows that emanate from the outside or inside edges of the layer contents.
- *Bevel* and *Emboss* add combinations of highlights and shadows to a layer to simulate the stated effects.

Figure 3-51. Layer Style Menu. Add an artistic effect, such as shadows, to images. Selecting an effect from this menu launches a dialogue box with options to configure the effect.

The easiest way to add a layer style is to click on the Add a Layer Style icon (which resembles an *f* in a circle) at the bottom of the Layers palette (fig. 3-51). Layer styles cannot be added to a Background layer—but if you double click on the Background layer, you can convert it to a regular layer and proceed. The Layer style is appended to the layer and can be subsequently modified or hidden if desired.

Selecting Blending Options from this menu, or double clicking on the layer (but not the name of the layer), yields the default Layer Style dialogue box, shown in figure 3-52. Layer effects can be selected from the left side of the dialogue box, while blending options are available on the right.

Layer Masks. Layer masks allow one to hide, or mask, part of a layer. Thus, a layer mask can hide part of an image on a layer containing pixels or can limit the effect of an adjustment layer to selected portions of an image. A layer mask is automatically added to an adjustment layer when it is created and appears as a white rectangle to the right of the layer thumbnail. A layer mask can also be added to any other layer (except a Background layer) by clicking the Add Layer Mask icon (which appears as a circle within a rectangle) at the bottom of the Layers palette.

If a selection is active at the time a layer mask is created, this selection will be applied to the layer mask. Selected areas will appear as white on the layer mask, nonselected areas as black, and partially selected areas as shades

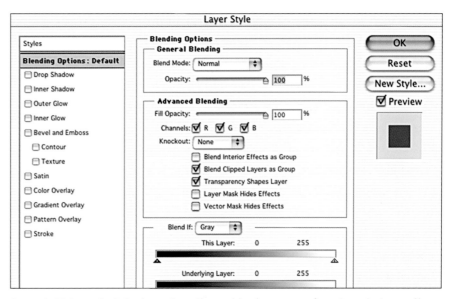

Figure 3-52. Layer Style Dialogue Box. Choose blending options from the right, layer effects from the left. To access the dialogue box with options for a layer effect, click on the name of the effect (not just the check box).

of gray. Functionally, layer masks may be viewed as equivalent to selections. Just as a selection can be converted to a layer mask, a layer mask can be converted to a selection (most easily by Cmd/Ctrl clicking on the layer mask thumbnail).

Layer masks can be modified by any tool or filter that can be applied to a grayscale image. For example, one can paint on the layer mask with black to add to the mask (the hidden area) or with white to subtract from it (thereby increasing the selected area). If you have difficulty remembering whether to paint with black or white to achieve the desired effect, a mnemonic may help: black blocks (the layer effect). On a layer with pixels, click on the layer mask thumbnail before modifying the mask, or else you will apply the effect directly to the image pixels. When the layer mask is active, a double border will appear around its thumbnail; in addition, the layer mask icon will appear to the left of the layer thumbnail. To display the layer mask in the image window, Opt/Alt click on the layer mask thumbnail. To view the layer mask as a color overlay on the image, press the "\" key. Repeat these commands to return to the standard image view.

Channels Palette. Photoshop uses grayscale channels to store an image's color information and masks. If an image has multiple layers, each layer has its own set of color channels. RGB images have four channels (one for each of the red, green, and blue components plus a composite channel used for editing the image; see fig. 3-53). Similarly, LAB images have four channels, whereas CMYK images have five channels.

Channels can also be utilized to create and save masks, known as alpha channels. An alpha channel can be created by clicking on the Create New Channel icon at the bottom of the Channels palette. To create an alpha channel from an active selection, click on the Save Selection As Channel

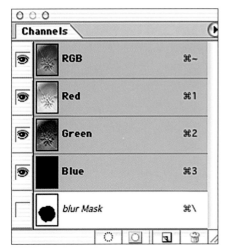

Figure 3-53. Channels, RGB. The Channels palette for an RGB image shows the composite and individual color channels. In addition, when the active layer contains a mask, the Channels palette shows the mask channel below the color channels; in this case, a mask is present on a Layer entitled "blur." The icons (from left to right) at the bottom of the Channels palette allow one to load the channel as a selection, save a selection as a channel, create a new channel, or delete the current channel.

icon. To create an alpha channel from a layer mask, Cmd/Ctrl click the layer mask to load the mask as a selection and then save the selection as a channel; alternatively, highlight the layer with the layer mask to make the mask visible as a channel below the color channels in the Channels palette, then drag that mask to the Create New Channel icon to copy it.

Selecting a mask channel reveals an 8-bit grayscale layer that can be modified by painting or erasing the mask. Even though alpha and other mask channels are saved with images in PSD format when layers are saved, they are not active unless loaded as a selection by Cmd/Ctrl clicking on the mask channel or layer mask or by highlighting the mask channel and clicking the Load Channel As Selection icon at the bottom of the Channels palette.

History Palette. You can use the History palette to revert to a previous state of an image or to delete the image's states. You can also replace an existing document with a selected state by dragging it onto the document.

The History palette allows one to go to any recent state of an image created during the current working session. Each time an image is modified, the new state of that image is added to the palette. If an earlier state is selected from the History palette, the image will revert to its appearance when the change reflected by that state was initially applied. If you choose to work from that state, the subsequent states will be deleted unless you choose nonlinear history (probably best reserved for nonlinear thinkers). Should you make a change to an earlier state and immediately change your mind, you can restore the eliminated states by using the Undo command—but this will only undo the last thing you did. If the number of history states specified in the preferences is exceeded, the earlier states will be deleted as new states are added. When you close the image file, all information will be deleted from the History palette, including the snapshots.

From the photographer's perspective, the History palette is extremely important as a means of reverting back to a state before an error or undesired result. In conjunction with the History brush, it can be used in innovative ways to apply effects from one state to another, as previously illustrated (fig. 3-33). For example, if I made a mistake using a painting or cloning tool, I could position the History brush at an earlier state and then paint over the error to remove the undesired effect while preserving the remainder of the image.

Tips. Finally, here are some helpful tips that will allow you to more efficiently use Photoshop.

- When using the Move tool, press Control and click (Mac only) or right click (PC) to see the layers with pixels under the cursor. This is particularly helpful when using layer masks, as it allows one to determine which layer effects have been applied to a given area of an image.

THE HISTORY PALETTE ALLOWS ONE TO GO TO ANY RECENT STATE OF AN IMAGE....

IMAGES ARE A LITTLE SHARPER
ON THE SCREEN WHEN VIEWED
IN EVEN MULTIPLES OF 100%.

- Images are a little sharper on the screen when viewed in even multiples of 100% (including 50% and 25%).
- To return to the original values in a dialogue box, hold down Opt/Alt key and click the resultant Reset button.
- Press the Cmd/Ctrl key to temporarily disable the "snap to" function, manifested by lines snapping to the edge of the image, etc. To turn off the "snap to" function, select View>Snap or View>Snap To>None.
- With the Zoom tool selected, you can click and drag over any area of the image to have it fill the work area.

SHORTCUTS

[Reduce Brush Size
]	Increase Brush Size
Spacebar	Hand Tool
Cmd/Ctrl	Move Tool
Tab	Hide or Show
Toolbox/Options Bar/Palettes	
Shift Tab	Hide or Show Palettes
Opt Delete (Mac)	Fill with Foreground Color
Alt Backspace (PC)	Fill with Foreground Color
Cmd Delete (Mac)	Fill with Background Color
Ctrl Backspace (PC)	Fill with Background Color
Ctrl Tab	Scroll through Open Windows
Cmd/Ctrl Spacebar Click	Zoom In
Opt/Alt Spacebar Click	Zoom Out
Cmd/Ctrl +	Zoom In
Cmd/Ctrl -	Zoom Out
Cmd/Ctrl 0	Zoom to Fill Screen
Opt/Alt Cmd/Ctrl 0	Zoom to 100%
Cmd/Ctrl O	Open File
Cmd/Ctrl N	New File
Cmd/Ctrl A	Select All
Cmd/Ctrl D	Deselect
Cmd/Ctrl F	Last Filter
Cmd/Ctrl R	Rulers
Cmd/Ctrl H	Hide or Show Extras
Cmd/Ctrl J	Layer via Cop
Cmd/Ctrl K	General Preferences
Cmd/Ctrl S	Save
Cmd/Ctrl T	Free Transform
Cmd/Ctrl Z	Undo or Redo

4. Creating the Master Image

In this chapter, I will describe in a logical sequence the steps I recommend to produce a master image. Central to this concept is the creation of a master image file that is large enough to produce the largest print one would ever want with little or no upward interpolation. The rationale is that image quality is compromised by scaling the file size upward to produce larger prints but not by scaling downward for smaller prints.

To create the master image, I typically begin with a transparency, which represents the starting point in this chapter. If you are starting with input from a digital camera, open the image in Photoshop and proceed to the section entitled "Analyze the Scan."

CLEAN THE SLIDE

Carefully spray the slide with Dust Off or a similar product, holding the can upright. Spray parallel to the surface of the slide to minimize the risk of damage to the emulsion. If more aggressive cleaning is necessary, use Pec-12 Photographic Emulsion Cleaner and Pec pads—or use the tools in Photoshop.

I SCAN VIRTUALLY ALL OF MY IMAGES IN MY DIGITAL DARKROOM.

SCAN THE IMAGE

I scan virtually all of my images in my digital darkroom. However, if you do not have a transparency scanner or need an image file larger than your scanner can generate (even with interpolation using Photoshop or other software), you may need to utilize the services of a commercial lab. The highest quality scans are created using drum scanners. When contracting with a commercial lab to perform drum scans on my images, I request file sizes of about 100MB for 35mm slides and 150–200MB for larger formats.

Some persons advocate obtaining a 300MB file for the larger formats, and this is reasonable if you expect to produce prints with dimensions 30 x 40 inches (or equivalent size) or larger. Do not perform any sharpening during the drum scan. Request that the image be profiled with either the Ekta Space or Adobe RGB (1998) color space.

A less expensive commercial alternative is a Kodak Pro Photo CD scan, which adds an image size of 4096x6144 pixels with an uncompressed file size of 73.7MB (at 8 bits/channel) to the standard Kodak Photo CD pixel dimensions. My experience suggests that these scans can produce results similar to drum scans for 35mm transparencies.

The disadvantages of using commercial labs for scans include higher cost and the potential for damage during transit or when the transparency is removed from the mount prior to scanning. In addition, for drum scans the transparency is placed in a liquid (hopefully not oil) to eliminate the air–transparency interface before being taped to the scanner drum.

If you have a commercial scan, open the image in Photoshop. If you have a drum scan, it will probably be saved in an uncompressed TIFF format. Save a copy of this image in Photoshop (PSD) format (File>Save As). Close the TIFF file and use the Photoshop file for subsequent processing.

A LESS EXPENSIVE COMMERCIAL ALTERNATIVE IS A KODAK PRO PHOTO CD SCAN. . . .

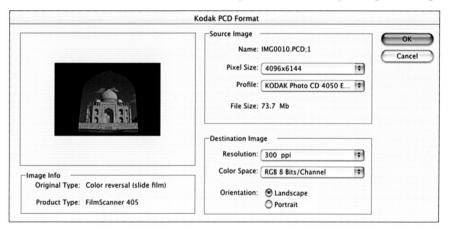

Figure 4-1. Kodak PCD Format Dialogue Box.

Proceed to "Analyze the Scan" on page 60. If you have a Pro Photo CD, start Photoshop, click File>Open, and locate the folder entitled Images within the Photo CD folder. After you select the desired image file from the folder, the Kodak PCD Format dialogue box will open, presenting you with the thumbnail and several options. Choose the largest pixel size (4096x6144 pixels) and the appropriate profile. For Fuji or Ektachrome film, find the image profile containing E-6. For Kodachrome, find the profile containing K-14 (but depending upon how your transparency was scanned, you may derive better results using the E-6 profile). For the destination image, specify the desired resolution (usually 300 dpi), color space (usually RGB 8 bits/channel, but LAB and 14 bits/channel are also options), orientation, and click OK. The image format will be converted to Photoshop and the colors to your default RGB color space (unless you

Figure 4-2. File Import. To scan from within Photoshop, open your scanner software as depicted.

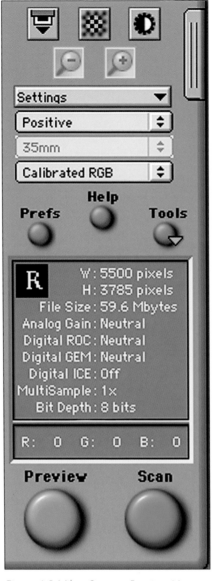

Figure 4-3. Nikon Scanner Preview Menu.

chose LAB). Consequently, verify that you are working in the desired color space before opening the image in Photoshop. Proceed to the next section.

In my darkroom, I utilize the Nikon 8000ED scanner with Nikon Scan software, which I find convenient and easy to use. Similar software accompanies scanners from other manufacturers and is also available as stand-alone programs from third-party vendors.

VERIFY THAT YOU ARE WORKING IN THE DESIRED COLOR SPACE BEFORE OPENING THE IMAGE....

If supported by your operating system, the scanner program can be launched from Photoshop (File>Import>Nikon Scan or appropriate program; see fig. 4-2), in which case the file is opened within Photoshop at the completion of the scan. Photoshop cannot be used for any other purpose while the scanner is acquiring the image. Alternatively, the Nikon Scan application can be launched directly from the desktop, in which case the image file is saved to the hard drive for later processing. I recommend the latter approach when creating large image files (especially for images larger than 35mm) or whenever scanner processing seems slow, as this bypasses Photoshop and allocates maximal memory to the scanning application.

After the scanner has been turned on and the scanning application launched, insert a clean slide or negative into the scanner. Review the scanner options from the menu (fig. 4-3). For the Nikon scanner, select Kodachrome only for Kodachrome film and Positive for Ektachrome or

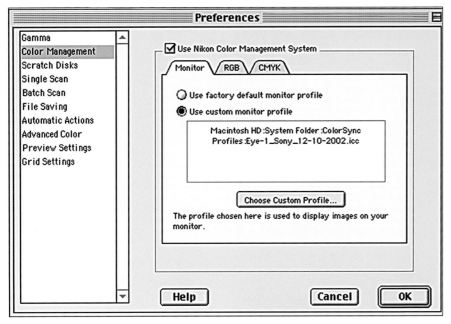

Fuji (including Velvia) transparencies. Verify the size of the transparency to be scanned.

Select your scanner's color management options (Prefs button>Color Management using the Nikon Scan interface; see fig. 4-4). I use Nikon color management. Choose the custom monitor profile created when you calibrated and profiled the monitor, rather than the factory default setting. For RGB, I use Adobe RGB (1998), both for PCs and Macs (regardless of what Nikon says about different gammas). (If you have cre-

Above—Figure 4-4. Nikon Scanner Preferences. **Right**—Figure 4-5. Nikon Scan Image Preview. The bull's-eye targets the area to be focused.

ated a separate profile for your scanner, follow the appropriate steps to utilize that profile.)

After you have finished specifying preferences, click the Preview button to view a small resolution scan and select additional options for the full resolution scan. The image preview will appear in a box that can be stretched to fill your available monitor area (fig. 4-5). If you are using two monitors, you can drag this window to your larger monitor. Your image will be surrounded by "marching ants" that indicate the area to be scanned. Position the cursor over any border that needs to be adjusted and, when the cursor changes to a double-headed arrow, drag the edge to reposition the scanning area. I generally leave a little of the border around the image, since it is difficult to determine the precise crop from this image. For Nikon scanners, hold down the Opt (Mac) or Ctrl (PC) key and click on the focus but-

I GENERALLY LEAVE A LITTLE OF THE BORDER AROUND THE IMAGE.

ton (the checkered box in the middle of the top row), then position the cursor over the center of the slide or the most important region and press or release the button to manually focus the scanner at that position (depicted by the bull's-eye). Follow the analogous procedure to focus other scanners.

Next view the settings for Tools. Change the orientation of the image if appropriate. Set the image file size to the maximum available resolution for the scanner with a scale of 100%, thereby creating the largest file possible for your master image (fig. 4-6). This will yield an image file size of about 58MB from a 35mm slide at 4000 dpi.

Figure 4-6. Nikon Scanner Tool Palettes. One can change the orientation of the image, adjust Curves, specify Scan Bit Depth, apply a small amount of Unsharp Mask, and enable Digital ICE™ using scanner tools. In the preview scan histogram shown, pixels are well distributed throughout the tonal range without clipping of shadows or highlights.

The palettes depict a histogram of the image with curves that can be adjusted, as in Photoshop. Details are necessary in both the shadows and highlights for an optimal scan, and burned-out highlights are especially devastating for transparencies. If the image is significantly overexposed or underexposed, one can apply some adjustments to the curves controls before performing the scan, but under such circumstances I generally prefer to scan at 14 bits/channel and make adjustments in Photoshop. Otherwise, scanning at 8 bits/channel is usually adequate and provides the benefit of being able to use adjustment layers on the images in Photoshop. If processing the scan in Photoshop does not yield satisfactory results, one can scan the image twice, once for shadows and again for highlights, and combine these scans in Photoshop. It is usually not necessary to sample the image more than once, although multisampling is an option that may be utilized if needed to minimize noise and extract details from dark shadows.

I often apply a small amount of sharpening during the scan, but you should experiment with your own system. If sharpening introduces too

I OFTEN APPLY A SMALL AMOUNT OF SHARPENING DURING THE SCAN.

Top—Figure 4-7. Histogram. The histogram for this image reveals many pixels in the mid-tones and a paucity in the highlights. This simply reflects the characteristics of the subject (shown in fig. 3-14). No clipping is observed. **Bottom**—Figure 4-8. Levels. This histogram from another image, viewed in Levels, reveals significant clipping in the shadows and suggests a potential problem with the scan. However, the spike in the shadows is primarily due to the black border around the image, which will be cropped subsequently.

ONCE THE PREFERENCES HAVE BEEN CONFIGURED, YOU CAN SAVE THEM FOR FUTURE USE.

much grain in the sky, you can decrease or eliminate the sharpening in the blue and cyan channels. Or you may elect not to sharpen the image during scanning. For extreme grain, Digital GEM may be applied; of course, you will lose detail throughout the image. Once the preferences have been configured, you can save them for future implementation (Settings>Save Settings>Normal, or whatever name you wish).

Some scanners include Digital ICE, a hardware–software combination that digitally removes dust from non-Kodachrome color films such as Ektachrome and Fuji films (using Digital ICE on Kodachrome slides can produce some bizarre edge effects). Although I have found Digital ICE to be a very useful feature, it appears to soften some images slightly. I recommend scanning with Digital ICE in the Normal setting, but for images where sharpness is critical, consider performing a second scan without Digital ICE during the same session. This second scan should not take too long, since the scanning area has already been defined, the scanner is focused, and your computer does not have to perform the additional processing required for Digital ICE. For images with significant grain, the slight softening achieved by the application of Digital ICE may be desirable.

When you have completed the Tools adjustments, press Scan. Once the scan is complete, open the image in Photoshop to begin the digital processing.

ANALYZE THE SCAN

Before proceeding with image processing, you should first analyze the quality of your scan. Evaluate the image histogram (Image>Histogram or Image>Adjustments>Levels) to determine the number of pixels in the shadows, midtones, and highlights. In a good scan, the histogram should reveal pixels distributed across the entire range. Pixels grouped at the left end of the histogram indicate clipping in the shadows, whereas pixels grouped at the right end of the histogram indicate clipping of the highlights. If pronounced, you may need to rescan the image with adjustment of curves toward shadows or highlights. An absence of pixels at the extremes of shadows or highlights in the histogram is not a concern at this stage, as this can be corrected in Photoshop.

THE FINAL AND MOST IMPORTANT WAY TO EVALUATE YOUR SCAN IS VISUALLY.

A second way to evaluate the information contained in your scan is to study the RGB color channels. Each channel may be considered to represent a mask that acts as a filter for that color. For each of these channels, white areas represent the respective color at full intensity, whereas black areas represent absence of that color. If a color that should be prominent in the image is lacking in its respective channel, you may choose to perform a new scan, making color adjustments during the scan.

The final and most important way to evaluate your scan is visually. If the scan looks good, that is more important than histograms and channels.

SAVE THE IMAGE FILE

Save the image file to a separate folder on your hard drive, such as My Scans. Name the file FILE_NK_SCAN.PSD or any nomenclature you wish, but be consistent. If you have applied sharpening during the scan, you may want to indicate the parameters in the file name. For example, FILE_S10-6-3_NK_SCAN.PSD. However, this can easily get out of control. I recommend that you record information regarding adjustments or other scanning settings, especially the sharpening parameters and any changes to the default settings, using the File>File Info tool or a notebook.

Now save the image again, this time as FILE_NK_MASTER.PSD or your preferred terminology. After you have completed processing this image, this file will become your master image. By saving it now with a different name, you will not accidentally overwrite your original scan

Figure 4-9. RGB Channels. The color channels for the image shown in the previous figure.

when you save it. Photoshop shows this image as the Background layer on the Layers palette.

SET THE IMAGE STATUS BAR TO SHOW THE IMAGE SIZE

Click on the status bar triangle at the bottom of the application window (PC) or document window (Mac) to select Document Sizes. (The status bar is always visible with the Mac OS but with Windows may need to be activated using Window>Show Status Bar.) This step may seem unimportant now but will help prevent inadvertently overwriting the master file with a smaller file when the file is later resized for printing.

DUPLICATE THE BACKGROUND LAYER

Add a copy of your image on the layer above the Background layer. One option is to open the Layers palette menu (click on the triangle at the upper right of the Layers palette) and choose Duplicate Layer. However, an easier method is to drag the Background layer to the New Layer icon at the bottom of the Layers palette, just to the left of the trash can (fig. 4-10). If you wish to name that layer something other than the default name of Background Copy, hold down the Opt/Alt key as you drag the layer.

<div style="float:left;width:40%;text-align:center;">PERFORM ANY PIXEL MODIFICATIONS ON THE COPY OF THE BACKGROUND LAYER.</div>

Figure 4-10. Duplicate Background Layer.

Although creating a copy of your Background layer will increase the image size, I recommend that you perform any pixel modifications on the copy of the Background layer. If you make changes to the Background Copy layer that you need to undo but cannot accomplish from the History palette, you can always go back to the Background and make another copy to start over or to revise a portion of the original pixels. After you have completed all modifications to the master image file, you may delete the Background layer (not the copy) if you wish to decrease the file size. Since the Background layer should be identical to your originally saved file, assuming you followed the steps above, you really do not need to keep it. If you delete this layer, make certain that you can locate and identify the original scan file. Alternatively, you may elect to maintain the Background layer with the original image pixels and delete the original scan file after you have completed the master image file. In this latter case, the border of the final file will be cropped, in contrast to the original scan, but that should not create any future problems as long as you have not cropped into the image.

CROP AND ROTATE THE IMAGE

Trim. If the image is surrounded by a border of a single color or transparent pixels, the Trim command (Image>Trim) can be used to crop that bor-

der. This may be useful when your image is surrounded by a black border created by a slide mount. For other cropping, proceed to the Crop tool.

Crop Tool. For the best view of the image, select Fit On Screen (Cmd/Ctrl 0). Then use the Crop tool to crop the region around the slide, removing any visible portion of the slide mount or other border (fig. 4-11). At this point, I do not recommend that you crop within the image itself, unless you are absolutely certain that you will never want to use those pixels again. If you scanned a slide in a cardboard mount, the corners will appear rounded. You may crop them out or use the Clone tool to fill them in. Press Enter to perform the crop.

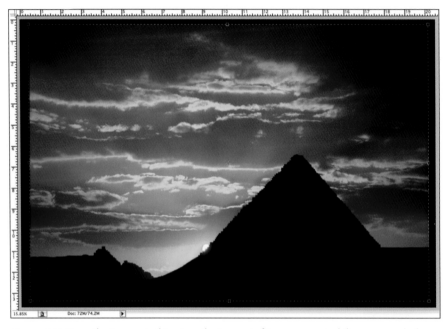

Figure 4-11. Crop the Image. In this view, the image is fit on screen and the crop marks have been placed in the approximate location for cropping. Zoom to a 100% magnification to precisely position the crop marks.

If the image is rotated, you can use the Crop tool to correct the orientation and crop the image in a single step. After clicking and dragging on the image to define the area to be cropped, move your cursor outside the bounding box (you may need to zoom out from the image to see the bounding box). Notice that the cursor changes to a curved double arrow. Drag the cursor to rotate the cropping marquee to the desired orientation and recheck the edges of the marquee. You can pull a guide out from the ruler bar (Cmd/Ctrl R to show) to identify the true horizontal or vertical axis. Click Enter to complete the operation.

Rotate Canvas. For precise rotation of an image, a better option exists. Choose the Measure tool, located on the fly-out menu attached to the Eyedropper on the Toolbox, and draw a line on the image along a border that should be horizontal or vertical (fig. 4-12a). I most often use this tool to straighten a tilted horizon, in which case I draw a line along the horizon to indicate the orientation that should be horizontal. Choose Image>

IF YOU SCANNED A SLIDE IN A CARDBOARD MOUNT, THE CORNERS WILL APPEAR ROUNDED.

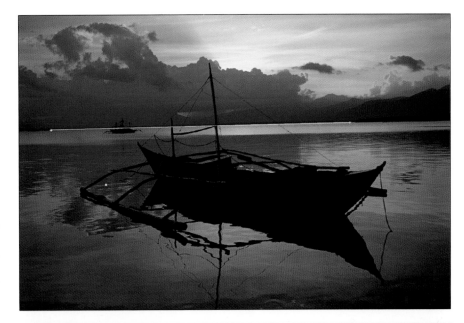

DEFER ROTATING THE CANVAS
UNTIL YOU HAVE MADE ALL
OTHER CORRECTIONS....

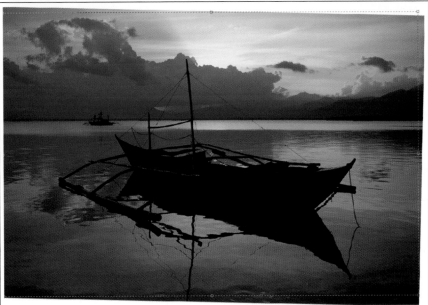

Figure 4-12. Rotate Canvas. **Top**—(a) A line has been drawn along the tilted horizon in this image using the Measure tool. **Bottom**—(b) By rotating the canvas an "arbitrary" amount (which is hardly arbitrary), the horizon is automatically straightened—but the image is tilted. The best method to correct the orientation may be to crop the image as indicated by the crop marks and then clone pixels to fill the right-hand portion of the upper sky.

Rotate Canvas>Arbitrary and click OK. Voilà! The image has been rotated to the correct angle. As a consequence, though, the image will now appear tilted (fig. 4-12b). To correct this, recrop the image and/or use the Clone Stamp tool to fill in the missing pixels along the border. Since cropping a tilted image will result in loss of pixels, you may want to defer rotating the canvas until you have made all other corrections, then save the file with a different name before rotating and cropping to create the master image file. (The reason for this sequence is to minimize the amount of work should you later decide you want to vary the amount of the rotation.)

CHECK THE EDGES

Not uncommonly, despite careful cropping, a bit of black border will remain along some portion of the image, often because the photograph was not completely horizontal/vertical when it was cropped. Enlarge the image to at least 100% and drag the red box in the Navigator palette around each of the edges in the thumbnail image to check for areas without image pixels (fig. 4-13). Pay special attention to the corners.

Figure 4-13. Edge Check. With the above photograph enlarged to 100%, and the red Navigator box positioned in the upper left-hand corner, it is evident that there are black areas in the corner and along the left side that will require additional cropping and/or cloning.

SPOT THE IMAGE

With the Background Copy highlighted and the image at 100% magnification, use the Clone Stamp tool to remove any dust and defects (fig. 4-14). Start with a 35–45 pixel diameter soft brush, resetting the hardness to 25% and the spacing to 20%.

Check the entire image, starting in the upper left-hand corner, moving down the image one screen at a time (Page Down) until you reach the bottom, then moving one screen to the right (Cmd/Ctrl Page Down), moving up by one screen at a time to the top of the image, moving right by one screen, and so forth.

After you have cloned dust and defects from the image, repair any other areas of the image that require correction. As with dust removal, you will usually use a soft brush as specified above. If you need to create a sharper edge, use a harder brush. If larger areas require correction, sample from different regions so pixel repetition will not be obvious. If the initial efforts are not optimal, move back through the History palette to undo changes or, if necessary, copy the area to be redone from the Background layer onto

IF YOU NEED TO CREATE A SHARPER EDGE, USE A HARDER BRUSH.

THE HEALING BRUSH AND PATCH
TOOLS CAN BE USED TO
FACILITATE IMAGE REPAIR.

Figure 4-14. Spotted Image. **Top—**(a) After selecting the source area, position the Clone Stamp tool over defects as shown. **Bottom—**(b) Both the Clone Stamp tool and Healing Brush were used to rejuvenate this slide.

the duplicate layer and try again. If you scanned a transparency in a cardboard mount and have rounded corners, you may clone out those areas if you wish; if not, you can remove them during the final crop. The Healing Brush and Patch tools can be used to facilitate image repair—they are especially helpful when you want to blend pixels into a problem area rather than replace the area.

After you have completed spotting the Background Copy layer and are satisfied with your results, double click the layer name and rename it Spotted or Cloned. That way you will know you have modified the layer

Figure 4-15. Levels Adjustment. **Top**—(a) Image before levels adjustment. **Center Row**—(Left) (b) A new Levels adjustment layer identified by the histogram icon has been added above the image layer. (Middle) (c) Double-clicking the adjustment layer icon reveals the Levels dialogue box containing the image histogram. (Right) (d) The Levels dialogue box shows the adjustment of the highlight slider from 255 to 194.

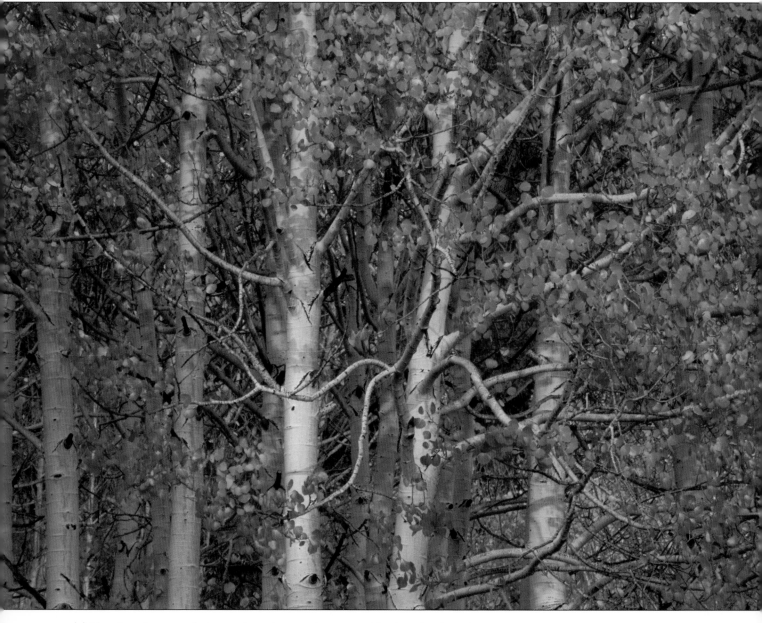

(e) After the adjustment, the image shows increased contrast with a broader dynamic range.

and that the image has been spotted. In fact, it is a good idea to give each layer in your image a name that indicates its function, especially with complex layering.

There may be instances where you are not sure if the scanned image will produce an acceptable print. In such cases, you may wish to defer the rotation, cropping, spotting, and cloning until you have applied adjustments in contrast, brightness, and color to determine whether the image is a "keeper."

ADJUST THE OVERALL CONTRAST

Levels Adjustment Layer. One technique to modify image contrast is to create a new Levels adjustment layer. By using an adjustment layer, no pixels in the image are altered. To illustrate this method, we will start with the scanned image of red aspen shown in figure 4-15a. I created a new Levels adjustment layer by clicking on the white and black circle icon at the bottom of the Layers palette and choosing Levels. This new layer appeared above the image on the Layers palette (fig. 4-15b). I was also presented with the Levels dialogue box containing a histogram that shows the proportion of image pixels at various levels of brightness, from black on the left to white on the right (fig. 4-15c). Notice that the highlight area for this image, at the right end of the histogram, lacks pixels. As a result, this image lacks contrast, because its pixels do not span the full dynamic range from 0 to 255.

To improve the contrast, I reset the highlights by dragging the right input slider from its default position at 255 (white) to the left until it reached the area with pixels (fig. 4-15d). Any pixels to the right of the highlight slider were reset to white, and the intensity values of pixels to the left were shifted accordingly, creating a more dramatic image (fig. 4-15e).

One consequence of adjusting levels is that detail is lost in the shadows and highlights. When using this method, click the Preview box on and off to see the effect of your changes and make certain they are acceptable. If this does not provide optimal adjustment of contrast, create a Curves adjustment layer, which provides more control (see below). To reset this, or any dialogue box, back to its original state, click Opt/Alt to transform the Cancel box into a Reset option.

Should one wish to decrease the contrast in an image, this can be accomplished by moving the output sliders at the bottom of the Levels dialogue box in toward the center. In this case, one would be decreasing the dynamic range of the image. Normally I would not change these output settings unless I were sending my image for process printing.

In some instances, the Levels histogram may depict scattered pixels from uncertain regions of the image within the highlight and shadow areas. To determine whether these are desired pixels, or to identify the lightest or

BY USING AN ADJUSTMENT LAYER, NO PIXELS IN THE IMAGE ARE ALTERED.

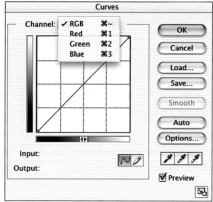

Left—Figure 4-16. Red Aspen Highlights.
Above—Figure 4-17. Curves. The default curve, shown here, exerts no effect on the image in Normal blending mode.

darkest areas of an image, move the right input slider all the way to the right and then back to the left while the Opt/Alt key is depressed until the first colors appear against the black background. These represent the highlights, depicted above in red for the aspen image (fig. 4-16). The shadows can be similarly identified by moving the left input slider all the way to the left and then back to the right until the first colors appear against the white background, indicating the shadows. If desired, these highlight and shadow areas can be marked on the image using the Color Sampler tool (which is accessed by holding down the Shift key with the Eyedropper tool selected).

CURVES ADJUSTMENT LAYER

An alternative method of adjusting the contrast is to use Curves. As with Levels, Curves should be applied as adjustment layers so that no pixels in the image are modified. If one has created a particularly difficult curve, the curve can be saved and reloaded to make changes or to be applied to another image.

A curve depicts the relationship between the input and output color values: the abscissa (horizontal axis) represents input values and the ordinate (vertical axis) output values. The default curve is a straight line from the 0,0 position at the lower left of the graph to 255,255 at the upper right, indicating that the input and output values are identical (fig. 4-17). Curves can be applied to all color channels (RGB in this instance) or the individual color channels. To adjust overall contrast, use the default selection, which affects all color channels.

The boxes showing the specific input and output numbers become accessible after the curve is clicked. Add points to the curve by clicking the desired location; delete points by dragging them out of the graph. To select

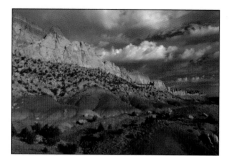

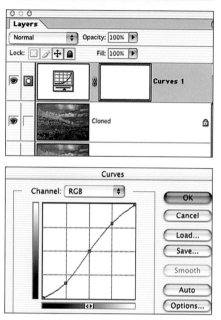

Figure 4-18. Curves Adjustment. **Top**—(a) Original scan. **Center**—(b) A Curves adjustment layer is positioned over the cloned layer, which in turn resides above the original scan. **Bottom**—(c) The Curves dialogue box shows an S-curve that increases image contrast.

the values for a particular region, click on that area of the image and move the mouse around, observing the region of the curve selected by this maneuver. By clicking on a segment of the curve and pulling it up and to the left, the output numbers are increased with respect to the input numbers, lightening those shades in the image. Likewise, clicking on a portion of the curve and dragging it down and to the right will darken those pixels.

To appreciate the power of Curves for adjusting contrast, consider the vista in figure 4-18a. This image was photographed as the first rays of morning light illuminated the golden cliffs, producing dramatic and vivid colors. Although the original transparency conveys the contrast and colors, the scanned image does not. Instead, it appears relatively flat and dull. However, this is typical of the output from my scanner. To correct the image, I will add a Curves adjustment layer above the image (fig. 4-18b).

Before adjusting the contrast in your image, view the Curves graph with a 4x4 grid. If a 10x10 grid is depicted, Opt/Alt click within the graph to convert it. Now position a point at each position where the curve intersects the grid (i.e., at $\frac{1}{4}$, $\frac{1}{2}$, and $\frac{3}{4}$ of the distance from 0 to 255). By adjusting each of these points up or down, one can increase or decrease the brightness and adjust the contrast in the shadows, midtones, and highlights. Figure 4-18c depicts a curve in which the three-quarter tones have been lightened and the one-quarter tones darkened. However, the highlight and shadow values have not been affected (since 0 in equals 0 out and 255 in equals 255 out), assuming the image contains pixels at those points. The result is increased contrast in the mid-range values, where the slope of the

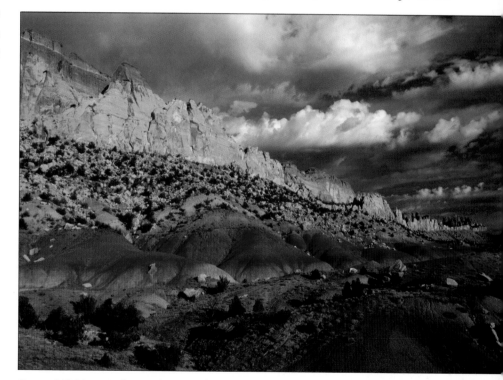

Figure 4-18d. Image after application of S-curve.

curve has been increased, and decreased contrast in the shadows and high-lights, where the slope of the curve has been decreased. Applying this curve to the image heightened the drama of the sunrise (fig. 4-18d).

Applying Curves often increases the saturation or causes color shifts in an image. If this produces an undesirable effect, change the blending mode of the layer from Normal to Luminosity. For complex adjustments, one may utilize multiple curve adjustment layers.

Additional examples of Curves adjustments and how they compare to Levels are shown in figures 4-19a–f. As you can appreciate, adjusting the contrast with Curves offers much more control than using Levels. On the other hand, Levels adjustments are easier to perform and often sufficient. The decision as to which method to use is largely personal.

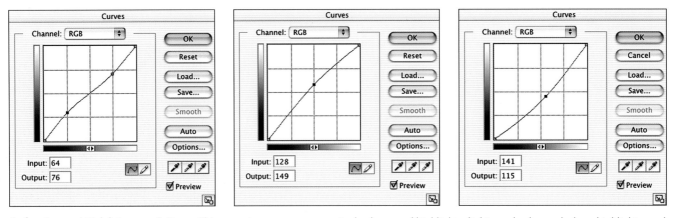

Left—Figure 4-19 (a). Reverse S Curve. This curve increases contrast in shadows and highlights, lightens shadows, darkens highlights, and decreases midtone contrast. **Center**—Figure 4-19 (b). Convex Curve. This curve lightens midtones especially, producing the same effect as moving the midtone slider in Levels to the left. **Right**—Figure 4-19 (c). Concave Curve. This curve darkens midtones especially, producing the same effect as moving the midtone slider in Levels to the right.

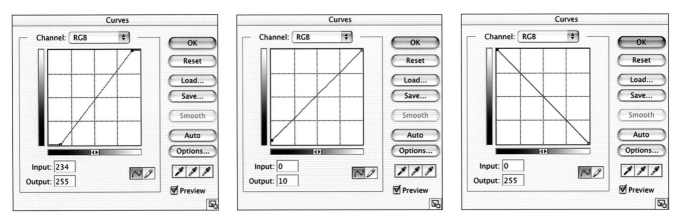

Left—Figure 4-19 (d). Z-Curve. This curve decreases dynamic range by changing white and black points and increases contrast. This is the same effect achieved in Levels by moving the left and right input sliders inward toward the midtones. **Center**—Figure 4-19 (e). Step-Up Curve. This curve lightens shadows and decreases contrast. This is the same effect produced in Levels by moving the left output slider to the right. **Right**—Figure 4-19 (f). Flipped Curve. This curve would only be used to produce special effects. What does it do? (If you are stymied, check the answer posted on my Web site [visit www.hamiltonphoto.com].)

Levels Adjustment Layer. If you used Levels to adjust contrast, you can use the same dialogue box to adjust the brightness of an image by moving the midtone (gamma) slider. Moving the slider to the left shifts the midtones toward the shadows, thereby increasing the gamma value and lightening the image. In contrast, moving the slider to the right darkens an image.

To illustrate this technique, I started with a somewhat dark image of reflected grass blades (fig. 4-20a). Then I moved the Levels midtone slider to the left from its default value of 1.0 until it reached 1.30 (fig. 4-20b), which lightened the image (fig. 4-20c).

Curves Adjustment Layer. If you used Curves to adjust the contrast, you probably adjusted the brightness at the same time. However, you may want to modify it further at this point. To lighten image midtones, pull the

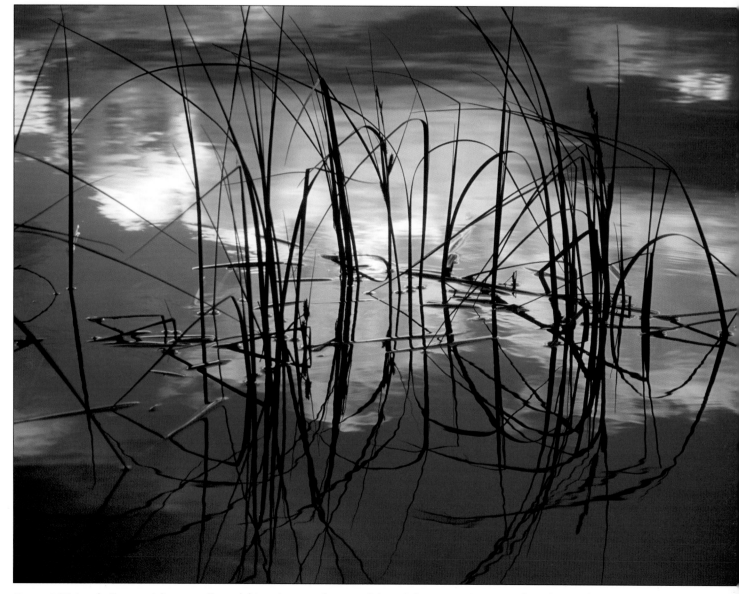

Figure 4-20. Levels Gamma Adjustment. **Top**—(a) Initial image. **Center**—(b) Levels histogram showing midtone (gamma) slider moved to left. **Bottom**—(c) Brighter image.

center of the curve up and to the left (fig. 4-19b). To darken the midtones, pull the curve down and to the right (fig. 4-19c). Since adjustments with Curves permit one to specify the output value for each of the 255 input levels, they offer an incredible amount of flexibility and control over contrast and brightness.

Blending Mode Layer. An alternative method to darken or lighten an image is to apply the Multiply or Screen blending mode to a duplicate layer.

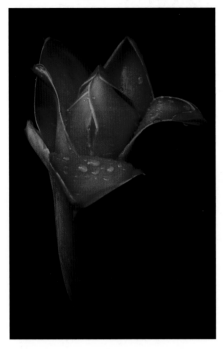

Figure 4-21. Blending Mode Adjustment. **Left**—(a) Dark image. **Right**—(b) Layers palette with new adjustment layer in Screen blending mode. **Facing Page**—(c) Screen adjustment layer applied to image.

To lighten a dark image, such as the torch ginger in figure 4-21a, create a new Curves adjustment layer by clicking the black/white circular icon at the bottom of the Layers palette and selecting Curves from the menu. When the Curves dialogue box appears, click OK without making any changes. Now change this layer's blending mode (located at the top of the Layers palette) from Normal to Screen (fig. 4-21b), which lightens the entire image (but does not affect white or black), improving the overall exposure of the flower (fig. 4-21c). If an image is still too dark at this stage, you can apply the effect again by duplicating the Curves adjustment layer. If this produces too much lightening of the image, reduce the opacity of the layer.

To darken an image that is too light, follow the same steps as above, but change the blending mode of the duplicate layer to Multiply. If the image is still overexposed, create a second or even third duplicate layer using the Multiply blending mode. If the Multiply effect makes the image too dark, lower the opacity of the upper layer until you achieve the optimal exposure.

Notice that I was able to apply the blending mode via Curves adjustment layers without changing the shape of the curves—but had I modified the curves, I could have refined the adjustment layer to apply the blending mode differentially as a function of image tonality.

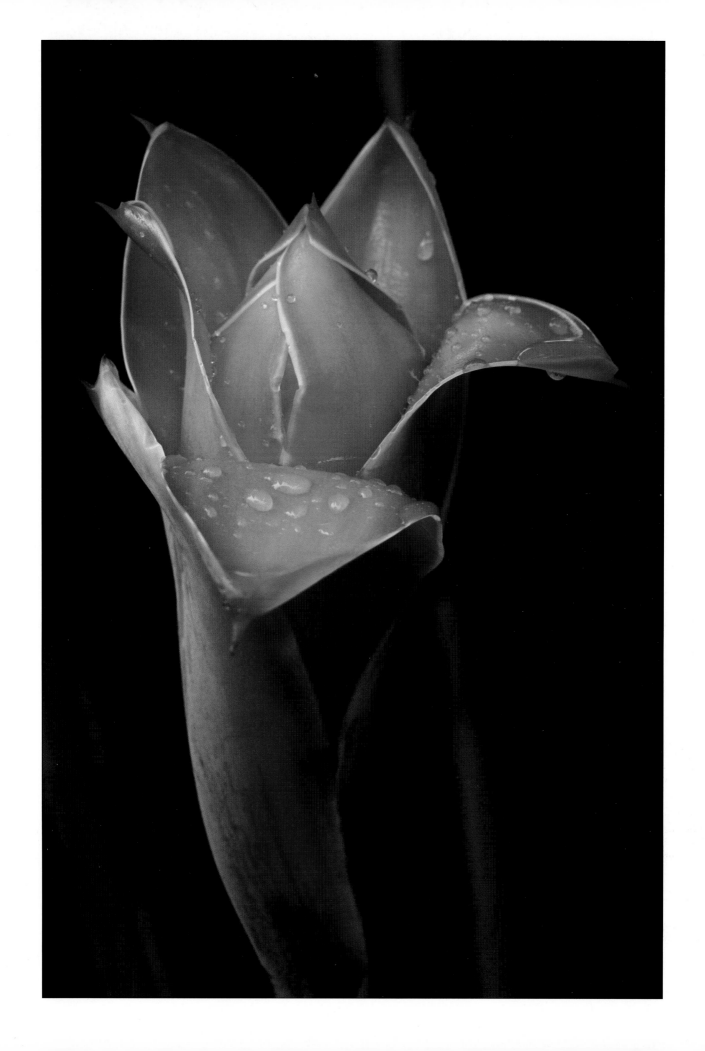

Color Balance Adjustment Layer. Add another adjustment layer, this time for Color Balance, and look at the color balance in the image midtones as you move each of the color sliders to the left and to the right. Each slider controls the balance between one of the additive colors and its complementary subtractive color. Try to find a balance that removes unwanted color casts or otherwise improves the colors. Changes in these settings produce a relatively large effect and will usually be small. Keep the Preserve Luminosity box checked to maintain tonal balance. If you need to remove color casts in the highlights or shadows, click the appropriate buttons and evaluate small changes in the Color Balance.

In the following photograph of an adobe church in late afternoon, the sky appears overly cyan (fig. 4-22a). As the initial step toward correcting this, the color balance was shifted from cyan to red by moving the top slider to the right (fig. 4-22b). This not only decreased the cyan cast but also warmed the church, corresponding to its actual appearance (fig. 4-22c).

Figure 4-22. Color Balance Adjustment. **Top Right**—(a) The initial image after cloning and Curves adjustment. **Bottom Right**—(b) The Color Balance dialogue box shows that I increased red (decreased cyan) in the midtones. **Above**—The image after applying the Color Balance Adjustment.

Left—Figure 4-23. Levels, Red Channel Color Adjustment. Move the midtone slider to the left (which increases the gamma value) to lighten reds. The effect is similar to adjusting the Color Balance. **Right**—Figure 4-24. Curves, Red Channel Color Adjustment. Pull the curve up to lighten the reds. This curve changes the reds qualitatively the same as moving the midtone slider in Levels.

Levels or Curves Adjustment Layer. Another technique for adjusting the color balance utilizes a Levels adjustment layer. Instead of applying the changes to all channels, as I did when adjusting the overall contrast and brightness, I will apply these changes to individual color channels. Open the red channel and move the midtone (gamma) slider to the left to lighten the reds (fig. 4-23) or to the right to darken them. Perform the same maneuver on the blue and green channels if appropriate.

Alternatively, color balance can be modified using a Curves adjustment layer by selecting a color from the Channel selection (fig. 4-24). Applying adjustments to the individual red, green, and blue color channels in Curves provides maximal control over the brightness and contrast of each color.

The effect of changing the color balance with Levels or Curves is similar to that accomplished with Color Balance. However, Color Balance allows us to preserve the luminosity and requires fewer maneuvers for adjustments. On the other hand, for complex color adjustments, Curves offers unlimited flexibility.

To restore neutral color balance to an image with an unwanted color cast, one can select the midtone eyedropper (the middle button above the Preview option) from either the Levels or Curves dialogue box and click a portion of the image that should be middle gray—Photoshop modifies each color channel to make this adjustment. To view the changes, select the individual color channels. This technique can also be applied to the shadows and highlights in the image. In some instances, such as sunrise or sunset pictures, you will not want a neutral image.

For the wildflower shown in figure 4-25a, I *did* want neutral colors. The original scan yielded a flat image with a strong blue color cast. In order to neutralize this, I opened a new Levels adjustment layer and initially selected the midtone eyedropper. I clicked on several neutral colors in the image to preview the effect. This adjustment improved the image somewhat, but

COLOR BALANCE CAN BE MODIFIED USING A CURVES ADJUSTMENT LAYER.

Figure 4-25. White Point Adjustment. **Top Left**—(a) Original scan. **Bottom Left**—(b) Levels dialogue box, highlight eyedropper selected. **Right**—(c) Image after white point adjustment.

the white petals still had a bluish cast and lacked contrast. I next selected the highlight eyedropper (indicated by the arrow in fig. 4-25b) and clicked on the lightest area in the image (on the upper margin of the left petal). This created a dramatic improvement in the appearance of the image, lightening the petals and eliminating the color cast, as shown in figure 4-25c.

In this example, I used the default highlight setting (R255, G255, B255). For images without a bright highlight, you will need to change the values assigned to the highlight eyedropper to use this technique successfully. To modify these default values, double click on the highlight eyedropper, which will open the Color Picker for the highlight values (fig. 4-26). Select the desired RGB values (keeping all values equal to maintain a neutral highlight) and click OK. To assess the results with this technique, specify highlight values in the range of 220 to 240 for each RGB channel, select the highlight eyedropper, and click over white areas in your image where you want to preserve some detail.

Selective Color Adjustment Layer. A selective color adjustment layer allows one to modify the color balance of the individual RGB and CMY colors, in addition to whites, neutrals, and blacks (fig. 4-27). Undesired colors in highlights can be corrected using the Whites selection, and neutral areas such as clouds can be adjusted with the Neutrals option. Selective Color also includes the option to adjust the amount of black in these channels. The major difference between Selective Color and Color Balance is that in Selective Color, the changes are applied to individual color channels in RGB or CMYK modes rather than to the entire image.

Top—Figure 4-26. Highlight Color Picker. **Bottom**—Figure 4-27. Selective Color. This dialogue box shows the colors and tones that can be modified by increasing or decreasing cyan, magenta, yellow, or black.

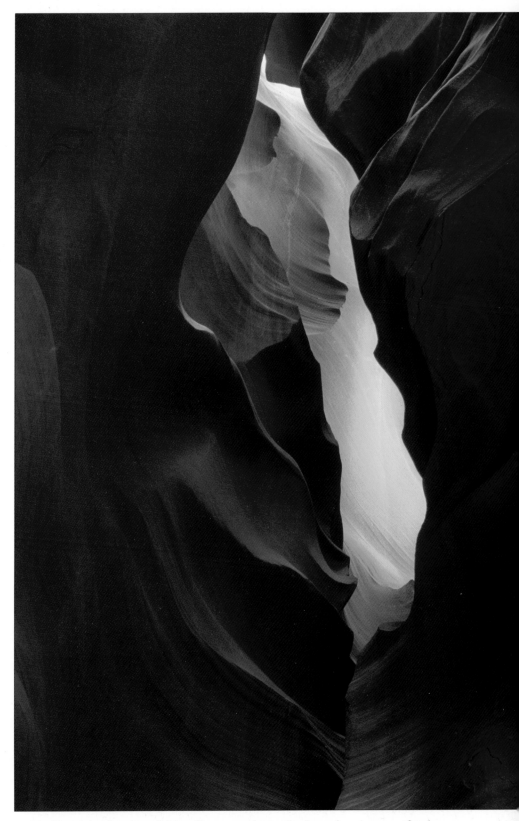

Selective Color Options

Colors: ☐ Yellows ⬍

Cyan: -60 %

Magenta: 0 %

Yellow: +60 %

Black: 0 %

Method: ● Relative ○ Absolute

OK
Cancel
Load...
Save...
☑ Preview

Figure 4-28. Selective Color Adjustment. **Top Left**—(a) Original scan. **Bottom Left**—(b) Selective Color dialogue box showing decreased cyan (increased red) and increased yellow adjustments limited to yellows. **Right**—(c) Image after selective color adjustments. These adjustments are greater than I typically make with this tool in order to demonstrate the effect.

To illustrate the use of this adjustment layer, I selected an image of a slot canyon with no adjustments after scanning (fig. 4-28a). On the original transparency, rich yellow tones with a golden cast characterize the slot opening. On the image file, however, the yellows pale by comparison. To enrich them, I selectively added red and yellow to the yellows as depicted in figure 4-28b. The effect of this adjustment is shown in figure 4-28c.

Hue/Saturation Adjustment Layer. Another technique for adjusting global color is to create a Hue/Saturation adjustment layer. As shown in figure 4-29, these adjustments can be applied to all colors (Master) or specific color components. To alter the hue, move the Hue slider to the left or right. The numbers in the Hue box indicate the degrees + (counterclockwise) or – (clockwise) around the color circle in the HSB model. The top color bar depicts the current colors; the bottom color bar will change as you move the slider to indicate how your adjustment will alter the present colors. If you have a sense of where you are going, this may be useful,

Figure 4-29. Hue/Saturation Dialogue Box. If an individual color is selected, the eyedroppers at the bottom of the dialogue box become available and can be used to sample specific colors from the image.

Figure 4-30. Hue Adjustment. **Top Left**—(a) Original image with yellow flowers. **Top Right**—(b) Hue/Saturation dialogue box showing Hue shifted by -40° within the yellows. **Above**—(c) Image after application of this Hue adjustment. I would not perform such a drastic adjustment without explicitly stating so.

Figure 4-31. Swirl Variations. Handle with caution.

but I generally use other methods. Nonetheless, it can produce interesting effects.

To illustrate this method, I chose a succulent with bright yellow flowers (fig. 4-30a). I then created a Hue/Saturation adjustment layer and changed the Hue within only the yellows (fig. 4-30b), thereby transforming the blossoms to a brilliant reddish-orange (fig. 4-30c).

Variations. I mention this tool primarily to discourage its use. Nonetheless, beginners may find it helpful to get an idea as to how color changes will alter an image (fig. 4-31). The color adjustments are relatively crude, the image pixels are altered when the adjustment is applied, and the image thumbnails are small. This option is accessed under Image>Adjustments>Variations. Just look, do not save anything here, then apply any desired color corrections using one of layer adjustment tools described earlier, such as Color Balance.

ADJUST THE OVERALL SATURATION

Hue/Saturation Adjustment Layer. Many images will benefit from having at least some boost in saturation. Create a Hue/Saturation adjustment layer and try increasing the saturation in amounts ranging from 5% to 15%, or even higher, to see if this improves your image. However, be careful not to overdo it. If there are any undesired color casts in the image, you can desaturate that color. Similarly, you can evaluate whether increasing the saturation of individual colors improves the image.

As an example of how increasing saturation can enhance an image, consider the photograph of a stream flowing over rocks, some colorful and some not. As expected, the colors in the scanned image were relatively dull, in contrast to the actual scene. After basic tone and color adjustments, the

image still appeared undersaturated (fig. 4-32a). I therefore created a Hue/Saturation adjustment layer and, because the image was so dull, increased the saturation by 25% (fig. 4-32b). The result is a more dramatic image with vivid colors in the red rock (fig. 4-32c). However, the bluish color in the water has now become objectionable. For more precise color correction, I modified the saturation of individual color components. First,

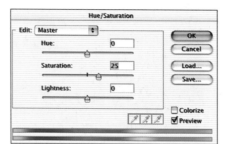

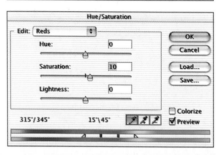

Figure 4-32. Saturation Adjustment. **Top Left**—(a) Image before adjusting saturation. **Top Right**—(b) Hue/Saturation dialogue box showing increased saturation. **Bottom Left**—(c) Image after increasing saturation. **Bottom Right**—(d) Dialogue box depicting increased saturation within the reds.

(e) Image after correcting reds and blues.

Figure 4-33. Lasso Selection. **Left**—(a) Selection defined by Lasso tool. **Right**—(b) Quick Mask of area outside the selection.

I selected blues and decreased their saturation by 50%. Then I selected reds and boosted their saturation an additional 10% (fig. 4-32d) to yield the final image in the sequence (fig. 4-32e).

SELECT PROBLEM AREAS

The previous discussion has considered global changes to the image. At this point, there will almost certainly be some areas in the image that will benefit from more attention. They may be too light or too dark or have a color cast. To apply changes to only a portion of the image, I generally create a selection within the image. This selection can then serve as the basis for a layer mask, which can be modified using the painting tools—painting with black adds to the mask and white subtracts from it. The white area of the layer mask defines the region of the image that will be affected by any adjustments.

Lasso. One of the easiest ways to create a selection is with the Lasso tool. Trace a rough selection using the Lasso, as shown in figure 4-33a, where I loosely lassoed an area I wanted to lighten. The sun was excluded from the selection. Feather the selection if desired (Select>Feather).

To edit the selection as a mask, type Q to enter the Quick Mask mode. The area outside the selection will now appear as a so-called rubylith mask (which appears red—unless you have changed its default color—but is really not; see fig. 4-33b) and form a temporary Quick Mask channel in the Channels palette. To save any changes you make to the Quick Mask channel, drag the channel to the Create a New Channel icon at the bottom of the Channels palette (you must do this before you exit Quick Mask). Type Q again to exit Quick Mask. I will return to this image later (fig. 4-39).

Color Range. This tool, found under the Select menu, allows one to make a selection based upon colors sampled with the Eyedropper (which appears automatically when the cursor is positioned over the image). The

TO VIEW THE SELECTION AS A MASK, TYPE Q TO ENTER THE QUICK MASK MODE.

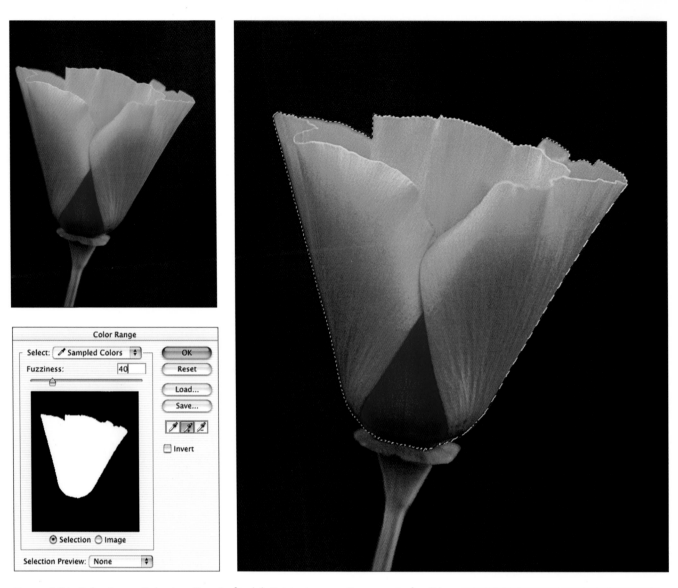

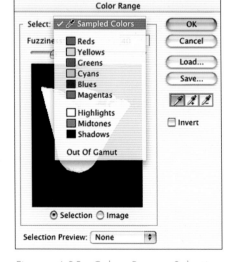

Figure 4-34. Color Range Selection. **Top Left**—(a) Original image. **Bottom Left**—(b) Color Range mask. **Right**—(c) Color Range selection applied to image.

Figure 4-35. Color Range Selection Options.

range of colors included as part of the selection is determined by the Fuzziness setting: higher levels encompass a broader range. This selection may be added to or subtracted from by clicking on the Eyedropper icons marked with a "+" or "–," respectively.

To make a selection based upon sampled colors from the poppy (fig. 4-34a), I opened the Color Range dialogue box, selected the additive eyedropper with a Fuzziness of 40, and clicked over the image of the poppy to create the mask depicted in the dialogue box (fig. 4-34b). If desired, an image selection created by Color Range can be viewed as grayscale, a Quick Mask, or against a black or white background (matte). When you have completed your selection, consider saving it for future use and click OK. The newly created selection is now applied to your image (fig. 4-34c) and can be used for subsequent adjustments (fig. 4-37).

In addition, Color Range can be used to make a selection based upon red, yellow, green, cyan, blue, magenta, highlights, midtones, shadows, or

out of gamut colors (fig. 4-35). Thus, analogous to Selective Colors, the color may be used as the basis for an operation, except with Color Range the result is a selection rather than a direct color change. Nonetheless, such a selection may form the basis for a color change or other actions. Moreover, these selections can be saved and reloaded either in Color Range or Replace Color (see below).

Channels. Oftentimes a convenient way to select an area is to duplicate one of the color channels and modify it to create a mask. This method is useful for creating a selection in images characterized by significant differences in contrast within at least one of the color channels (fig. 4-36a). Choose the color channel with the most contrast between the areas to be included and excluded within the mask (fig. 4-36b). Drag the layer to the bottom of the Channels palette to create a new channel (fig. 4-36c). Then use Levels to enhance the contrast by pulling the sliders toward the center (fig. 4-36d). Select the Paintbrush to paint white or black to modify the mask. To see the underlying image as you are creating the mask, turn on the eye icon for the RGB composite channel, which will simulate a rubylith mask. This mask is now stored as an extra layer in the Channels palette and can be loaded at any time by Cmd/Ctrl clicking on that layer.

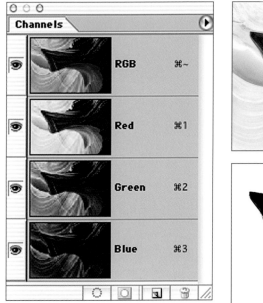

Figure 4-36. Channels Mask. **Top Left**—(a) The image. **Center**—(b) RGB Channels palette. **Top Right**—(c) The red channel. **Bottom Right**—(d) The mask created by applying a Levels adjustment to increase contrast in the red channel. This mask has been cleaned up slightly and can be further refined by painting on it with black or white.

ADJUST LOCAL COLOR

Any of the color adjustment tools used to effect global changes can also be applied to localized areas through the selection tools just described. By creating a new adjustment layer while a selection is active, a new layer mask will be created that limits the effect of the adjustment to the desired area without changing image pixels. All of the color adjustment methods discussed in this section—including Levels, Curves, Color Balance, Selective Color, and Hue/Saturation—can be utilized in this manner. This represents a simple but extremely powerful technique.

As an example, if I load the selection I created using the Color Range tool (fig. 4-34) and then, with the selection active, add a new adjustment layer, that selection will form a layer mask for the new layer, protecting any areas outside the selection from change (fig. 4-37a). To demonstrate this point, I created a new Hue/Saturation adjustment layer and modified the hue and saturation (fig. 4-37b) to create the dramatic but synthetic red California poppy (fig. 4-37c). Of course, these adjustments are typically much more subtle.

Replace Color. In addition to the above tools, there is a color adjustment tool that creates and modifies a selection: Replace Color. Accessed via Image>Adjustments>Replace Color, this tool uses an Eyedropper tool to select colors. Replace Color is not available as an adjustment layer. Unlike Color Range, the only selection option in Replace Color is sampled colors. However, a selection saved in Color Range can be loaded to create a selection in Replace Color. Changes in hue, saturation, and lightness can then be applied to the selected image—but they will permanently alter the image pixels. For this reason, I prefer alternative methods.

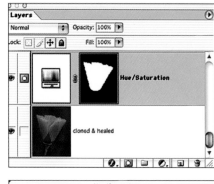

Figure 4-37. Localized Hue Adjustment. **Top**—(a) Color Range selection as the basis for a Hue/Saturation adjustment layer mask. **Bottom**—(b) Hue/Saturation dialogue box showing settings applied to image. **Left**—(c) Image modified through Hue/Saturation adjustment layer mask.

Figure 4-38. Replace Color. Although the transformation options are reminiscent of a Hue/Saturation adjustment, they cannot be applied through an adjustment layer and thus permanently alter the image pixels.

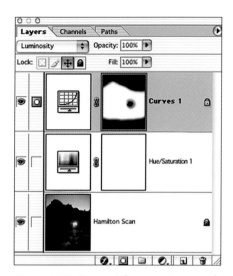

Figure 4-39. Curves Adjustment Layer with Masking. (a) Adjustment layer with mask.

Levels or Curves Adjustment Layer with Masking. After the problem area has been selected, using any of the techniques in the previous section, create a new Levels or Curves adjustment layer. The active selection will form the basis for the layer mask associated with this adjustment layer (fig. 4-39a). Opt/Alt click on the layer mask to display it in the image window (fig. 4-39b). Modify the mask as needed by painting on it with black to increase the mask (decrease the area affected by the adjustment layer) or with white to decrease the mask (increase the selected area). In order to see more clearly how the mask appears in relationship to the underlying image, go to the Channels palette. You will notice that the active channel is the one on which you are working. Click the box to the left of the RGB composite channel to see the underlying image through a mask that appears red. Switch between views as desired by clicking the RGB eye icon on or off. After you have completed your selection (which can be modified at any time as long as you preserve the layers in your file), return to the adjustment layer and Opt/Alt click on the Layer mask thumbnail to make the image reappear. Now the mask is not seen and the image should appear normal.

Double click on the adjustment layer thumbnail, in this case indicated by an icon depicting a histogram or curve, to reveal the Levels or Curves to be applied to your image through the layer mask. With Levels, start by moving the midtone slider to the left to increase the brightness. To increase the brightness and/or contrast of the selected area using Curves, pull the curve up and to the left (fig. 4-39c). To darken the selected area, move the midtone slider or curve in the opposite direction. With a Curves adjustment layer, you can protect certain tones from being changed by Cmd/Ctrl clicking on areas of the image with those tones. This will place correspon-

Left—(b) Layer mask (created by selection in figure 4-33), refined using the Paintbrush. **Right—**(c) Adjustment layer curve to lighten the unmasked area.

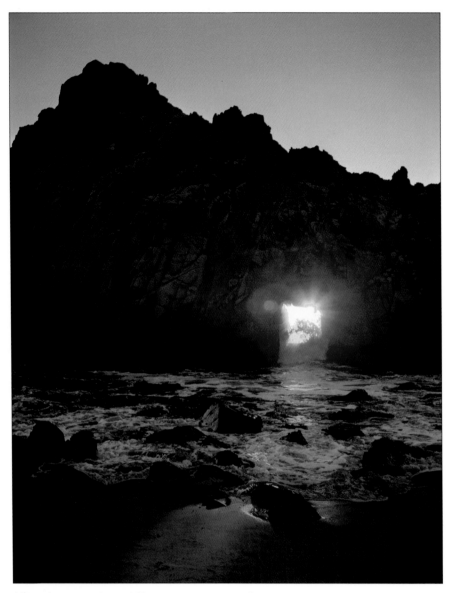

(d) Final image. What a difference a curve can make!

ding points on the curve that will remain fixed as you adjust the curve. When the adjustment is complete, pause to enjoy the view (fig. 4-39d).

Curves Adjustment Layer with Gradient Masking. Some images benefit from burning or dodging through a gradient mask. For example, the sky may be too light or dark along one corner of the image. Or, the portion of the image below the horizon may be too dark (perhaps you did not use a split neutral-density filter). In these and similar situations, applying a Curves adjustment through a Gradient layer mask may improve the image.

Create a new Curves adjustment layer. Since no selection is loaded, the layer mask appears white. Type D to set the background and foreground colors to their default values. Then select the Gradient tool (it may be hidden behind the Paint Bucket) and, in the Options bar, choose the Foreground to Background gradient, which usually appears by default. If necessary, use the Gradient picker to select it. Select the linear gradient

SOME IMAGES BENEFIT FROM BURNING OR DODGING THROUGH A GRADIENT MASK.

from the Options bar. With the new Curves adjustment layer highlighted, position the cursor over the area of the image needing maximal correction and drag the cursor along the desired gradient until you reach the end of the area you wish to correct.

Thus, to adjust a bright sky in one corner of the image, start near the corner of the image and create a relatively long foreground to background linear gradient angled down into the image. Dragging the cursor a longer distance will spread out the transition from white to black and thereby create a more gradual gradient than dragging it a short distance. Now double click on the Curves thumbnail on the adjustment layer to view the curve.

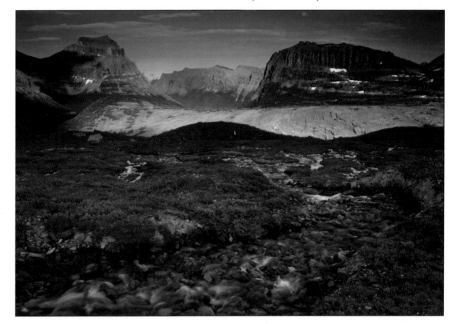

Figure 4-40. Curves Adjustment Layer with Gradient Masking. **Top Left**—(a) Initial image with underexposed foreground. **Center**—(b) Curves adjustment layer with gradient mask resembling split neutral-density filter. **Bottom Left**—(c) Curve applied to adjustment layer. **Right**—(d) Image after application of curve through Gradient layer mask.

To darken the unmasked (white) area, pull the curve down and to the right a small amount while observing the effect on the image. Use the up and down arrow keys to make small adjustments to the curve. You should notice darkening of the area to which you applied the gradient, greatest at the origin of the gradient.

The effect of a split neutral-density filter can also be achieved using a Curves adjustment layer with Gradient masking. Starting with an image with an underexposed foreground (fig. 4-40a), create a new Curves adjustment layer, and select the Gradient tool. With default foreground and background colors, draw a foreground to background linear gradient that starts below the horizon, runs upward at right angles to the horizon, and ends a short distance above it. When you release the mouse button, the gradient will be applied to the image, and the thumbnail depicting the layer mask should now resemble a split neutral-density filter (fig. 4-40b). Paint on the layer mask if necessary to refine the border between the light and dark areas. To lighten the unmasked area below the horizon, move the curve up and to the left, analogous to the adjustment in the preceding paragraph but in the opposite direction (fig. 4-40c). The application of this adjustment layer to a mountain stream image is shown in figure 4-40d.

You may need to experiment with the distribution of the gradient to achieve the desired effect. With the Gradient tool still active in Normal mode and the adjustment layer highlighted, just create another gradient within the image—it will replace the previous one. To limit the effect of the gradient, you can superimpose a Mode: Darken gradient (select from the Options bar) on the Normal gradient. This blocks the action of the linear gradient in the darkened area. For complex corrections, you may need to create more than one Curves adjustment layer, each with its own gradient.

Clone Stamp. I have found the Clone tool to be useful in some situations characterized by very bright highlights with little detail. By cloning with low opacity (try about 20%), it is possible to tone down the highlights and add some detail that is lacking. Depending upon the area to be adjusted, it may be helpful to isolate it with a selection before cloning. The Healing Brush and Patch tools may also be useful in this situation.

Blending Mode Layer. My preferred technique for applying localized burning and dodging is to create a new layer above the other ones and choose the Soft Light blending mode with 100% opacity, filled with soft-light neutral color (50% gray), as shown in figure 4-41. To burn or dodge an image, paint on this new layer using the Paintbrush tool with brush opacity setting of 10–15% (selected in the Options bar) and apply black paint to burn (darken) or white to dodge (lighten) problem areas in the image. With this reduced brush opacity, each brush stroke increases the effect (up to 100% opacity).

Continuing with the previous image after the application of the Gradient layer mask (fig. 4-40d), I created a new Soft Light blending mode layer. Then I painted in darker shades of gray (black with reduced brush opacity) over the neutral background to burn some of the less attractive or overexposed elements in the image (fig. 4-42a, b). This produced the mountain stream image shown in figure 4-42c.

For more dramatic burning and dodging, follow the above steps but choose the Overlay blending mode, which multiplies or screens the colors, depending upon the base color. Fill the new layer with the Overlay neutral color (50% gray) and paint with black or white to burn or dodge, respectively. With this technique, the image pixels are blended with white or black so as to reflect the lightness or darkness of the original image. Try setting the Paintbrush opacity from 5–15% in this mode. You can also choose the Airbrush, which produces a more dramatic effect than the Paintbrush, since the opacity continues to increase as long as the mouse button is depressed.

To increase saturation while preserving blacks, use the Color Dodge blending mode. Create a new layer filled with black, the neutral color for this effect. Choose a Paintbrush with a 5–15% opacity, and paint on this new layer with white to enhance key elements. Vivid Light combines Color Dodge and Color Burn to yield another blending mode that may be used to dodge or burn colors. Fill the new layer with Vivid Light neutral color

Figure 4-41. New Layer with Soft Light Blending Mode. Use this for subtle burning and dodging. To access this dialogue box, Opt/Alt click on the icon to create a new layer (not adjustment layer) at the bottom of the Layers palette.

(50% gray). Using a Paintbrush with low opacity, paint with black to darken the area or white to lighten it.

BURN THE EDGES

If desired, apply an edges burn to highlight the center of the image. To exert the most control over the area to be burned, use the Lasso tool to select the central portion of the image. Though less precise, the selection can also be made using the Elliptical Marquee tool.

Apply a large feather (Select>Feather) to this selection, then create a new Curves adjustment layer to change the selection into a layer mask on that layer. Select the layer mask and invert the mask with Cmd/Ctrl I or Image>Adjustments>Invert. The same result can be obtained by inversing (Select>Inverse) the selection, applying the feather, and creating a Curves adjustment layer. (Do not confuse inverting with inversing—the former reverses the colors, creating a negative image, whereas the latter interchanges the selected and unselected areas.)

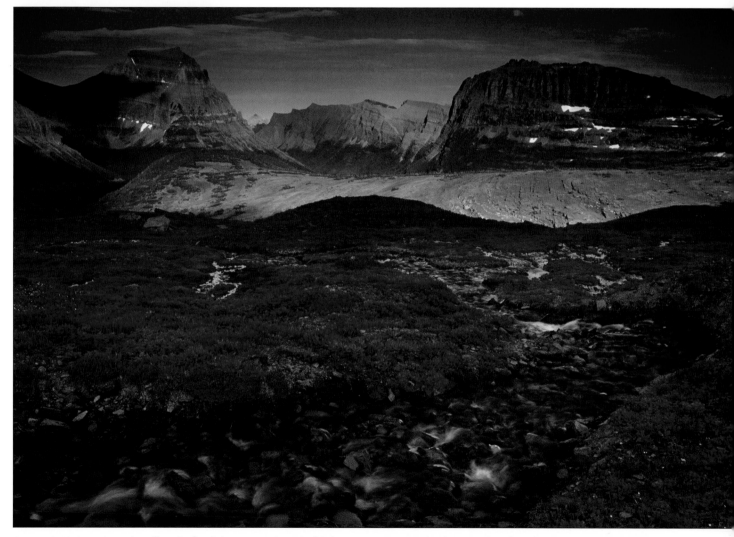

Figure 4-42. Burn & Dodge. **Top Left**—(a) Layers palette highlighting new Burn Dodge layer with Soft Light blending mode. **Bottom Left**—(b) Soft Light layer "full-screen" showing my painting skills. **Above**—(c) Mountain stream after burning to tone down selected areas.

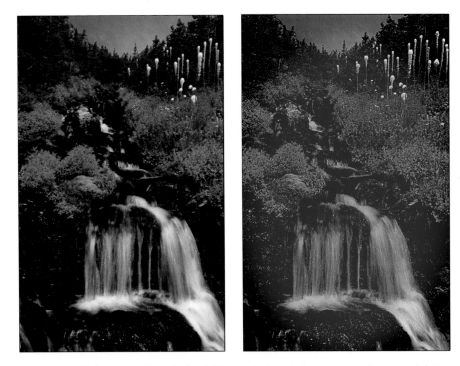

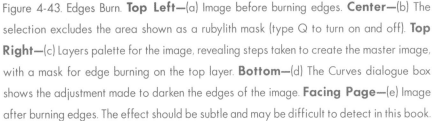

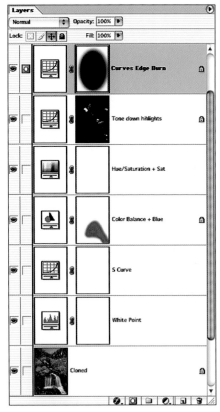

Figure 4-43. Edges Burn. **Top Left**—(a) Image before burning edges. **Center**—(b) The selection excludes the area shown as a rubylith mask (type Q to turn on and off). **Top Right**—(c) Layers palette for the image, revealing steps taken to create the master image, with a mask for edge burning on the top layer. **Bottom**—(d) The Curves dialogue box shows the adjustment made to darken the edges of the image. **Facing Page**—(e) Image after burning edges. The effect should be subtle and may be difficult to detect in this book.

Mask the central area of the image using one of the above techniques. For the image of a mountain cascade (fig. 4-43a), I used the Elliptical Marquee tool to select the central area, then inversed the selection (fig. 4-43b). With this selection active, I created a new Curves adjustment layer at the top of the Layers palette. The selected area now appears in white on the mask for that layer (fig. 4-43c). Double click on the new Curves adjustment layer thumbnail (not the mask) to open the Curves dialogue box, then pull the curve down a small amount to darken the edges of the image (fig. 4-43d). Use the up and down arrow keys for fine adjustments to the curve. This effect should be subtle and not consciously appreciated by the viewer (fig. 4-43e). Click OK when you are satisfied.

For some images, you may choose to enhance the central area by applying a center dodge rather than an edges burn. To do so, create a mask like that described for the edges burn but inverted so the central portion of the image will be lightened and the edges protected. Then pull the curve up to dodge the selected area. As with an edges burn, this effect should be subtle.

SAVE THE IMAGE AS THE MASTER FILE

At this point, you have completed the steps to produce the master image file. Save this file as FILE_NK_MASTER.psd or the name of your choice. This will overwrite the file of the same name that you created at the begin-

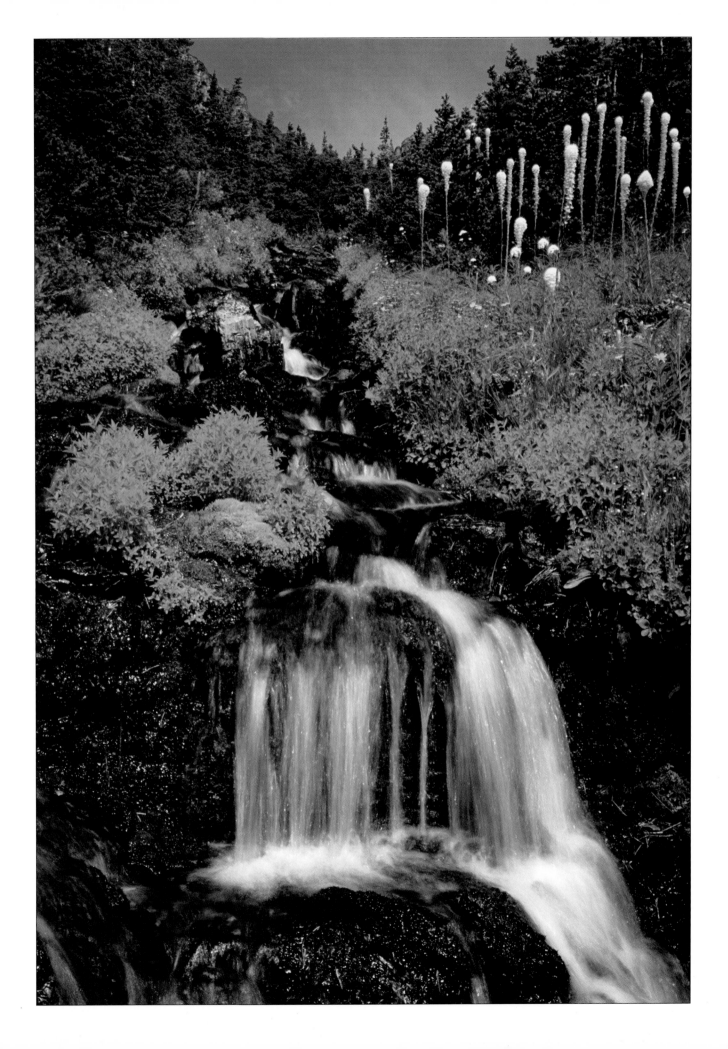

ning of the image processing. Do not modify this master file during any of the subsequent steps.

PRECISION TRIM THE IMAGE

With the image filling the screen (Cmd/Ctrl 0), use the Crop tool to apply the final cropping for the print. Discard any portion of the image you do not want in the print—you can always modify this when you make subsequent prints if you wish. Check the position of the crop marks with the image viewed at 100%. Fit the image on the screen again and, if everything looks correct, press Enter to perform the crop. Now click Cmd/Ctrl Z several times to undo and redo the crop to make certain that you are pleased with the final result. Depending upon how much effort you expended creating this crop and whether you want to be able to replicate it precisely in the future, you may wish to save this file, using a name such as FILE_NK_MASTER_CROP.psd. (You can also devise shorter names and include additional information in the File Info option.) If you are certain that you will never want to use any of the pixels you just deleted, you can make this your master image. If you are not sure, it is safest to keep both files, at least temporarily. If you wish to save space, this cropped master image file can be flattened. (Make sure you have the master image with all layers saved before you flatten this!) At some point you will develop a sense as to how much storage space you want to allocate for each image and act accordingly.

FLATTEN THE IMAGE

To prepare this file for printing, you need to flatten it—to reduce all the active layers to a single layer, discarding the hidden layers. Select Layer>Flatten Image. No longer can you edit the individual layers on this image. But it does not matter—you have saved the master image incorporating all these layers (I hope).

RESIZE THE IMAGE

Select Image>Image Size from the Menu bar and uncheck the Resample Image box. For inkjet printers, enter a resolution ranging from 240–360 pixels/inch in the resolution box. I routinely use 240 or 300 pixels/inch, but you can select 360 pixels/inch for maximal sharpness. For LightJet printers, enter a resolution of 80 or 120 pixels/cm (203.2 or 304.8 pixels/inch) or 200 or 300 pixels/inch (fig. 4-44), depending upon the model of the LightJet printer (the newer models have abandoned metrics) and how many pixels you have to spare (use the higher number if your image file supports it without much upward resampling).

Now you can see in the Image Size box the dimensions of the largest image you can print without resampling (i.e., resizing the image to be larger by adding pixels—generally not a good idea—or to be smaller by discard-

Figure 4-44. Image Size. This image has been resized upward just a bit for a 22 x 18-inch image at a resolution of 304.8 pixels/inch (120 pixels/cm) on the LightJet 5000 printer. The final size after the canvas is expanded will be 24 x 20 inches, as described on pgs. 95–96. The image proportions were initially constrained and were close to the dimensions listed; they were then unconstrained to round off to the dimensions as shown.

Figure 4-45. Unsharp Mask. **Top—** (a) Image at 100% magnification before sharpening. **Center—**(b) Specify Amount, Radius, and Threshold values in Unsharp Mask dialogue box. **Bottom—**(c) Image at 100% after sharpening with Amount 300, Radius 1, and Threshold 0. If the image appears unnaturally sharp when printed, try smaller values for the Amount or Radius.

ing pixels—usually not a problem). Place a check in the Resample Image box, make sure that Constrain Proportions is checked, and enter the longest dimension of your print, allowing a one-inch border on each side. Thus, for a print from a 35mm slide on letter size paper, enter 9 (inches) for the longest dimension. The other dimension will be entered automatically. If you want to tweak the dimensions slightly to round them off to even numbers, uncheck the Constrain Proportions box and enter the desired dimensions. For LightJet prints, record these numbers, because you will need them when you set your canvas size.

SHARPEN THE IMAGE

I routinely use sharpening tools to compensate for the loss of sharpness introduced during the process of creating a digital file. Sharpening is performed only after the image has been resized for printing and should be the last step applied before profiling or printing the image. If one chooses to save the sharpened image file, it should be clearly marked as to the image size (e.g., FILE_NK_S16x20.psd for a sharpened 16 x 20-inch file) and should only be used to print images of the same size—it should not be resampled. Nor should it be saved as the master file!

Unsharp Mask. One of the most commonly used Photoshop filters is the Unsharp Mask (Filter>Sharpen>Unsharp Mask). In the tradition of darkroom processing, the Unsharp Mask increases apparent sharpness by accentuating contrast along edges within the image. Three parameters must be specified: amount, radius, and threshold. Amount determines how strong the effect will be. Radius specifies how far (in pixels) the sharpening will extend from an edge. Threshold determines the difference between adjacent pixels necessary for an edge to be sharpened. A threshold of 0 sharpens everything in the image.

View the image at 100% magnification (fig. 4-45a) and start with an Amount of 150–200, a Radius of 1, and a Threshold of 0. Modify these values as appropriate for your image (fig. 4-45b, c). Large images will generally require a greater amount of sharpening than small ones. In adjusting these settings, it is important not to oversharpen the image, causing it to appear unnatural. This is generally manifested by the presence of halos along edges, although small halos seen on the monitor may not be visible on the print. If the image is destined for output on a LightJet printer, the amount should be adjusted so the image appears correctly sharpened as viewed on the monitor. For inkjet output, it may be permissible to slightly over-sharpen the image on screen, as dithering of the inks may cause some loss of sharpness—you will need to experiment to find the optimal settings.

A potential problem from sharpening is enhancement of the film grain in uniform areas such as the sky (not a problem with digital capture!). One way to minimize this problem is to create a selection that excludes the sky from the Unsharp Mask filter; another is to exclude the blue channel from

sharpening. The threshold value can also be increased slightly—this will decrease the appearance of grain but will also cause the other sharpened areas to lose sharpness, so be careful. If the sharpening effect seems too strong, apply the Fade command (Edit>Fade) to decrease it. One may learn to judge the appropriate amount of sharpening from the monitor, but the only reliable way to assess whether too much, or perhaps too little, sharpening has been applied is to view the print.

Sharpen Only Edges Action. This nifty action has been developed and modified by various Photoshop gurus and photographers over the years. Basically, it creates a mask through which the Unsharp Mask filter is applied to the lightness channel (LAB mode) of the image so that sharpening does not modify image colors. It is widely available in various permutations.

Miranda Edge Sharpen Action. Photographer and graphics artist Fred Miranda has created an alternative sharpening filter that produces results that seem similar to the Sharpen Only Edges effect. This filter may be downloaded from his Web site at www.fredmiranda.com and is certainly worth comparing to the Photoshop Unsharp Mask. A professional version of the Miranda action for 16-bit images is also available.

SOFT-PROOF THE IMAGE

With a color-managed workflow, it is possible to use color profiles to soft-proof an image directly on the monitor—to display on-screen a preview of the document's colors as reproduced by a specific printer or in a specific color space. Of course, factors such as the monitor, the quality of the profiles for the monitor and printer, and ambient lighting will influence the accuracy of the soft-proof. In addition, the appearance of an image produced by transmitted light (monitor) is never quite the same as that produced by reflected light (print), but within the limitations imposed by these inherent differences, it is possible to judge the appearance of a print with reasonable accuracy.

I use this technique to simulate how our images will look when printed from Epson as well as LightJet printers. Soft-proofing can also be used to simulate the appearance of an image in another color space. For example, you might wish to compare Adobe RGB (1998), which is probably your working space if you are scanning your own images, to Ekta Space, which is frequently used as the color space for drum scans.

To soft-proof your image, choose View>Proof Setup>Custom. In the Proof Setup dialogue box, you will be prompted to select the name of the Profile (fig. 4-46). Select the color profile matching the device and paper for which you want to create the proof. For Epson printers, choose a profile such as Epson Stylus Photo 1280 Premium Glossy Photo Paper or SP2200 Premium Luster_PK for prints from the Epson 1280 or Epson 2200, respectively, on Premium Luster photo paper. (The appropriate pro-

I USE THIS TECHNIQUE TO SIMULATE HOW OUR IMAGES WILL LOOK WHEN PRINTED. . . .

Figure 4-46. Proof Setup Dialogue Box. This profile is for the LightJet printer at Calypso Imaging using Matte paper.

Figure 4-47. Canvas Size Dialogue Box. Proper canvas dimensions for 22 x 18-inch image to add a one-inch border on each side.

file names vary slightly for different operating systems.) For LightJet printers, select your laboratory's profile for the type of paper you will use, such as Fuji matte, gloss, or supergloss. (LightJet profiles are available from commercial labs and can often be downloaded from their Web sites. If you download the profiles, you will need to install them into the proper directory for your operating system's color management system.) Follow the analogous procedure for other printers and papers. After selecting the appropriate profile in the Proof Setup dialogue box, save it as a custom setup with a name such as Epson 2200 Luster or Calypso LJ Matte v2. This name will now appear in the Proof Setup menu for future use.

Do not check the option to Preserve Color Numbers, because the goal is to simulate how the image will appear if colors are converted from the document space to their nearest equivalents in the proof profile space. Under Intent, select Perceptual and, for Photoshop 6 and higher, choose Black Point Compensation. Do not check Simulate Paper White or Ink Black.

You can toggle the soft-proof display on and off by selecting View>Proof Colors or by clicking Cmd/Ctrl Y. When soft proofing is on, a checkmark appears next to the Proof Colors command, and the name of the current proof profile appears in the image's title bar.

PREPARE THE IMAGE FOR THE COMMERCIAL PRINTER

Increase the Canvas Size. From the Menu bar choose Image>Canvas Size and enter dimensions for canvas height and width that are two inches greater than the height and width you previously selected as the image size (fig. 4-47). Click OK.

Stroking the image is necessary to define the margins at the edge of the canvas so the lab will know where to cut. To define the region to be

stroked, type Cmd/Ctrl A or, from the Menu bar, Select>All to select the entire canvas. Then choose Edit>Stroke. In the dialogue box, enter a width of 3–4 px (pixels) with black (unless your lab requests different settings), inside location, normal blending mode, and 100% opacity (fig. 4-48). After stroking the trim marks, deselect the image using the shortcut Cmd/Ctrl D.

Check Orientation of Image. Some laboratories require that images be submitted with the longer dimension oriented horizontally (landscape orientation). If your image is in the Portrait mode and you need to change it, choose Image>Rotate Canvas>90° CCW.

Apply Profile to Image. To prepare the image for a specific printer, you need to convert the image to the profile that characterizes the printer and paper (this is the same profile utilized for soft-proofing the image).

From the Menu bar, select Image>Mode>Convert to Profile. Then in the Convert to Profile dialogue box choose the appropriate Destination Space Profile, such as Calypso LJ5 Matte for LightJet print on Fuji Matte paper at Calypso Imaging (fig. 4-49). Always ascertain that you are using the current profile from your laboratory—check the company's Web site and call if there are any questions. I always use the Adobe ACE engine for color conversion. For Photoshop 6 and above, choose Perceptual under the Intent option and click the Black Point Compensation check box. Select the dither option. Click OK.

ALWAYS ASCERTAIN THAT YOU ARE USING THE CURRENT PROFILE FROM YOUR LABORATORY....

Top—Figure 4-48. Stroke Dialogue Box. **Bottom—**Figure 4-49. Convert to Profile Dialogue Box.

Save the File. Save the file to a temporary folder as a TIFF file without layers or channels (which there should not be at this point in any case). Do not overwrite any previous files. Be certain that the box specifying the ICC profile is checked and includes the proper profile. Don't use compression.

It probably does not matter if you use a PC or Mac format—most PCs can read Mac format and conversely. Choose a name that includes the dimensions of the image, including the border, such as NAME_18x22.tif for a 16 x 20-inch image with a one-inch border on each side. Send a copy of this file to the commercial laboratory and keep a copy for yourself until you have safely received the print—then discard it. I do not recommend keeping copies of files targeted for printers, because the profiles may be different the next time you need a print. In addition, the profiles for printers at different companies will most likely be different.

Copy the File. Copy the file to a portable medium. I recommend using a CD-R. Do not use CD-RW discs—they are not sufficiently reliable.

When copying files to a CD, you will be required to specify a format for the file name. A convenient option for Windows users is the Joliet file system, which allows long file names (up to sixty-four characters) for Windows 95 and later. However, many Mac systems read these names in the ISO 9660 file format, which recognizes names in 8+3 format (a ~ [tilde] will replace the other characters). If the recipient of your files is not able to read long file names in the Joliet system, Windows users will need to choose the ISO 9660 file system and may need to specify an eight-digit (or shorter) name for the file, not including the three-digit suffix that specifies file type. However, users of Roxio Easy CD Creator software can select the ISO 9660 file system with the option of long file names (thirty characters or less) that are readable by both Windows and Mac systems. Similarly, Roxio Toast Titanium software allows Mac users to create a CD using Mac OS extended and PC (hybrid) format to specify long file names that are recognized by both Mac and Windows operating systems.

WHEN COPYING FILES TO A CD, YOU WILL BE REQUIRED TO SPECIFY A FORMAT. . . .

When recording the CD, you will also have the option to write only the session (which allows additional files to be added at a later time) or to write the disc. To ensure that the recipient of your CD is able to read the files, I recommend writing the disc.

PRINT THE IMAGE ON YOUR PRINTER

In Photoshop, choose File>Print with Preview. The options will vary somewhat depending upon your printer and operating system, but in the appropriate dialogue boxes you should specify the paper size, type (Media), orientation, printer resolution (generally 1440 dpi), and print space profile. Set the printable area to maximum and select the centered option. Enable the print preview to verify the layout before you send data to the printer. The following dialogue boxes apply to Photoshop printing to the Epson Stylus Photo 2200 printer on Epson Premium Luster photo paper. They are included because choosing the proper printing settings represents a common source of problems in achieving an optimal print. The dialogue boxes may vary somewhat between operating systems and printers, but the options will be similar. See the figure captions for details.

DURING THIS PERIOD OF TIME THE COLORS MAY CHANGE SLIGHTLY.

Figure 4-50. **Top**—(a) Print with Preview (Cmd/Ctrl P). This dialogue box provides a preview of the image and allows you to select key settings. Specify the appropriate printer profile (such as for the Epson 2200 printing on Premium Luster paper as shown). Use perceptual intent and black point compensation. Verify the print size and orientation. Click the Page Setup button to view the dialogue box in the next figure. **Bottom**—(b) Page Setup. Choose the printer format, paper size, and orientation from this box. Click OK to select and return to the Print Preview dialogue box. Or select Options.

Allow at least twenty-four hours for prints to dry. During this period of time the colors may change slightly. In addition, to minimize "out-gassing" (which can fog the picture glass) when using resin-coated (RC) photo inkjet papers, the prints should dry up to two weeks before framing, unless accelerated drying techniques are utilized. To maximize print life, follow the ink and paper manufacturer's recommendations regarding appropriate

storage and display to minimize color shifts due to ozone and other environmental factors.

COPY THE MASTER IMAGE TO A CD

To protect the image file on which you have labored so diligently, I recommend that you make two copies on high-quality CDs. When you copy these files to the CD, use the Joliet file system (PC) or extended (HFS+) format (Mac), as they support long file names. Open the files from the CD to verify that they were burned correctly before you delete them from your hard drive. If possible, store one copy off premises, especially if it is a really special image.

THE BOTTOM LINE

In this chapter I have summarized the key steps to obtain a fine art digital print. Many of these steps describe alternative methods to achieve similar results. Individual preferences and the characteristics of a particular image

WHEN YOU COPY THESE FILES TO THE CD, USE THE JOLIET FILE SYSTEM OR EXTENDED FORMAT.

Figure 4.50. **Top**—(c) Options. When you click on Print in the Print Preview dialogue box, a series of options will become available, including this one for Print Settings. The settings shown here work well with Epson Premium Luster paper. Figure 4-50. **Bottom**—(d) Advanced. I have obtained the best results with No Color Adjustment option selected. Click OK and proceed to print.

determine the optimal techniques. The table below summarizes the key elements in creating the master image and may be referred to as you process your file.

These steps are quite straightforward and follow a logical progression. It is only as one delves into the intricacies of some of the adjustments that the process may seem complex. If you start with a well-exposed original, you can minimize the adjustments. If not, you will learn the nitty-gritty of Photoshop more quickly!

QUICK GUIDE TO THE MASTER IMAGE SEQUENCE

1. Clean the slide.
2. Scan the image.
3. Analyze the scan.
4. Save the image file.
5. Make a copy of the original scan image file and work on this copy.
6. Set the image status bar to Show the Image Size.
7. Duplicate the Background layer.
8. Crop and rotate the image.
9. Check the edges.
10. Spot the image.
11. Adjust overall contrast using a Levels or Curves adjustment layer.
12. Adjust overall brightness using a Levels or Curves adjustment layer.
13. Adjust overall color using Color Balance and, if needed, Selective Color adjustment layers.
14. Adjust overall saturation and check for color casts using a Hue/Saturation adjustment layer.
15. Select problem areas using the Lasso tool, Color Range, Channels, or other tools.
16. Adjust local contrast and brightness by applying Levels or Curves, Gradients, and Layer Blending Modes through layer masks.
17. Adjust local color and saturation through layer masks.
18. Burn the edges or dodge the center through layer mask.
19. Save and rename the image as the master file.
20. Make a copy of the master file and work on this copy.
21. Precision trim the image.
22. Flatten the image.
23. Resize the image.
24. Sharpen the image.
25. Soft-proof the image.
26. Profile or print the image.
27. Copy the profiled file to a CD-R if outsourcing it.
28. Copy the master file to one or more CDs.

5. Special Effects in the Digital Darkroom

FIELD EFFECTS

Despite the versatility of camera equipment and film, sometimes photographers lack the ability to create an optimal image in the field. We may find ourselves in the midst of scenery that would create a spectacular panorama, but lack an expensive panorama camera. We may wish to capture details throughout the range of a vista, but lack the depth of field in our lenses. Or we may want to record details in highlights and shadows that exceed the recording capabilities of our film. The good news is that we can accomplish all of these objectives without expensive photo gear or sacrificing our favorite film if we plan ahead and do a little extra work in the field to capture multiple images that can be combined in the darkroom.

Composite Panoramas. When photographing images to be combined in a panorama, both the tripod and camera must be leveled for optimal results. Each image for the panorama should be overlapped 20–50% with adjacent images. To facilitate blending in the panorama, each image should be photographed with the same exposure and scanned with identical settings.

To create the panorama, open each component image in Photoshop, crop to eliminate any edges, and rotate if necessary to level the horizon. If using the Crop tool or Free Transform command to straighten the horizon, use a horizontal guide pulled from the top ruler bar to judge your rotation. Use Image>Image Size to determine the pixel dimensions of each image at the desired printing resolution (usually 240–360 dpi) and create a new document at this resolution with a height and width sufficient to accommodate all of the component images. Do not discard pixels (downsize the images) unless the resulting composite file will tax your system's resources. For a

. . . USE A HORIZONTAL GUIDE PULLED FROM THE TOP RULER BAR TO JUDGE YOUR ROTATION.

horizontal panorama (which we will assume in this discussion), allow a little extra space along the vertical dimension of the new document in case the component images do not line up exactly. Due to partial overlapping of the component images in the panorama, it is not necessary to make the new document quite as wide as the sum of the widths of the individual images. However, it is better to err on the side of making the new document too large rather than too small—any excess can always be trimmed.

Using the Move tool, drag each of the images into the new document, starting with the left-most image and adding the adjacent images sequentially so that when flattened, the image layers will be correctly aligned (fig. 5-1). To begin the process of merging these images, hide the top image layer (click off the eye icon). Highlight the middle layer to make it active and, at the top of the Layers palette, decrease the opacity of this layer to 50%, as shown in figure 5-2a. Now you can see the middle layer superimposed over the lower layer. Move the middle layer until it is aligned with the lower layer. Enlarge the image to 100% (Cmd/Ctrl Opt/Alt 0) for precise alignment. For fine-tuning, use the arrow keys to move the image one pixel at a time. Switch back and forth between the 100% view and the Fit to Screen view as necessary to facilitate alignment. If the images do not align properly, you may need to use the Free Transform tool (Cmd/Ctrl T) to adjust the boundaries of the middle image. You can also use the Clone Stamp tool to fill in missing pixels. If you are having difficulty aligning the layers by reducing the opacity as described, you can temporarily invert (Cmd/Ctrl I) the middle image to create a negative image (fig. 5-2b). Now you will see an embossed effect created from elements of the middle and lower layers. When the layers are properly aligned, the embossing effect will be minimized; invert the middle image again to return it to its normal state.

Figure 5-1. Component Images in New Document. **Top**—(a) The component images of the panorama have been brought into a new document called Composite Flowers. **Bottom**—(b) Each image represents one layer in this new document. The middle image will be aligned with the left image, and then the right image will be aligned with the middle image, as described in the text.

Figure 5-2. Alignment of Left and Middle Images. **Left**—(a) Configuration of the layers, with opacity of middle layer reduced to 50% and the image inverted. **Right**—(b) The inverted middle image (on the right) was moved over the left image until the embossing effect in the central gray overlap area was minimized, indicating optimal alignment.

Figure 5-3. Alignment of Upper and Middle Layers.

To perform analogous blending of the upper two layers, configure the Layers palette as in figure 5-3, with the upper layer visible, at 50% opacity, and inverted. Now align the upper and middle layers using the same procedure as for the lower and middle layers.

Now that the layers are aligned, they must be blended. Turn off the eye icon for the upper layer so it is hidden (fig. 5-4). Create a new layer mask by highlighting the middle image layer and clicking on the New Layer Mask icon at the bottom of the Layers palette. Select the Paintbrush tool with a medium soft brush (hardness about 65%, spacing 20%), type D to set the foreground and background colors to their default values, and type X to exchange those values. Click on the layer mask you just created so that the changes you make will be applied to the mask and not the image pix-

Figure 5-4. Image Blending. **Left**—(a) Layers palette showing layer mask used to blend the middle and lower images. **Right**—(b) Appearance of the image interface during blending. Note the junction between the 2 images.

els. Now blend the two lower images together by painting on the layer mask with black (the current foreground color) to make the pixels on the lower layer visible or with white to bring back the middle layer pixels. Vary the size of the brush as needed to paint around detailed areas. If you have

difficulty blending the layers, apply a black to white linear gradient to the overlap region of the layer mask, starting near the left of the overlap and dragging toward the right across the overlapping region; this gradient mask can be refined as needed using the Paintbrush. After completing the masking, click the eye icon on the lower layer to hide it and check the mask you have created, cleaning up any stray pixels, then click the eye icon again to show the layer. To blend the upper and middle layers, return the opacity of the upper layer to 100%, add a mask to that layer, and paint the mask so the layers blend (fig. 5-5).

Despite using identical photographic exposures and scan settings, some adjustments in brightness and color may be required to match the component images (fig. 5-6). Determine which image demonstrates the best tonality and color—this will serve as a reference. Highlight the image layer that requires the most correction. Keep this layer and the reference layer visible but hide the other image layer. Press Opt/Alt and click the icon at the bottom of the Layers palette to create a new Levels adjustment layer. In the New Layer dialogue box that appears, type a name for the layer and check the Group with Previous Layer box. After you click OK, the Levels dialogue box will open. Move the input Levels midtone slider to the left or

HIGHLIGHT THE IMAGE LAYER THAT REQUIRES THE MOST CORRECTION.

Left—Figure 5-5. Layers palette with masks to blend all layers. **Right**—Figure 5-6. Component Layers and Adjustments in Panorama. This Layers palette appears complicated but is comprehensible if one approaches it layer by layer. A Levels adjustment has been grouped with the left image and a gradient layer mask modulates the effect of the Levels adjustment on the image. On the next layer up, the black portion of the layer mask blocks the left portion of the middle image, allowing the left image to be visible in that area. Levels adjustment and Hue/Saturation layers have been grouped with the middle image to limit their effects to that layer. Analogous operations have been performed on the right image. At the top of the Layers palette are Curves and Hue/Saturation adjustment layers that affect the entire image. This figure illustrates the inherent power of layers and masks—simple concepts with complex applications.

Figure 5-7. Composite Mums Panorama.

right to adjust the brightness so the images match. If necessary, pull the shadow and highlight sliders inward to enhance contrast. Alternatively, you can use a Curves adjustment layer to modify brightness and contrast—however, it is best to reserve this for situations when Levels adjustments do not provide satisfactory results.

If color adjustments are required, you may select from several techniques. These include adjusting the individual color channels using either a Levels or Curves adjustment layer, creating a Color Balance adjustment layer, or using a Hue/Saturation adjustment layer to modify either the hue or saturation of specific colors. I utilized a Hue/Saturation adjustment layer. Group this color adjustment layer with the layer being corrected so the adjustments will be limited to that layer. When these two images match, highlight the third image layer and apply similar adjustments so all images match. If necessary, adjust the corrections to the other layers to optimize the composite image.

When these operations have been completed, crop the image so all edges are straight. With this composite panorama, select the top layer, spot for dust or defects, and, if needed, adjust contrast, brightness, color balance, and saturation for the entire image using adjustment layers. For the mums composite, I adjusted contrast and saturation to yield the panorama shown in figure 5-7.

Whether applied to flowers or landscapes, the ability to create panoramas with relative ease in Photoshop is truly exciting. The approach described above can be applied to panoramas composed of more than three images, though the difficulty of matching the images seems to increase geometrically. If the above steps seem too arduous, you should be aware that third-party software programs can automatically combine your images into a finished panorama, though with limitations, including final image size.

Figure 5-8. Poppies. **Left**—(a) Image focused on left poppy. **Right**—(b) Image focused on right poppy.

Composite Depth of Field Masking. In the digital darkroom, I can increase the apparent depth of field of a lens to yield an image sharply focused throughout its range. To accomplish this requires a bit of planning. In the field, take two or three images positioned identically using a tripod but focused on different regions you want to ensure are sharp in the final image. For example, in landscape photography, take one photograph focused on a foreground element and another focused on a more distant element. With macro flower photography, take separate photographs of flowers at different distances from the camera, or even different portions of the same flower (fig. 5-8).

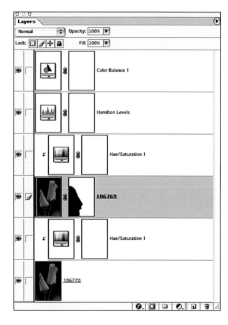

Figure 5-9. Layer Palettes for Combining, Masking, and Adjusting images. **Left**—(a) The right poppy has been positioned over the left poppy. **Center**—(b) A new layer mask was added to the upper layer and painted with black to reveal the sharp portions of the poppy on the lower layer. **Right**—(c) The Layers palette for the composite image shows the adjustments described in the text.

Figure 5-10. California Poppies, Composite Image.

In Photoshop, crop and rotate each component image of the composite as necessary. Using the same principles as described under panoramas, I will blend these images through a layer mask. While holding the Shift key, drag the layer from one image on top of the other image. This will align the centers of the images (fig. 5-9a). Lower the opacity of the upper layer to 50% and enlarge the image to 100% view to fine-tune the alignment. Create a new layer mask on the upper layer and paint on that mask with black to reveal (or white to hide) the lower layer (fig. 5-9b). With this technique, the sharp poppy from the bottom layer was revealed adjacent to the sharp poppy from the upper layer. When the depth of field for the composite has been optimized in this manner, follow the same steps as previously to create the master file. For the poppies, I created a Hue/Saturation adjustment layer grouped to each image layer so it affected only that layer (fig. 5-9c). When the saturation of these components was balanced, I applied Levels and Color Balance adjustments to the entire image to optimize contrast and color. The final image reveals an apparent depth of field that seems to defy the laws of optics (fig. 5-10).

Composite Contrast Masking. Using transparency film for landscape photography offers several advantages, and one major disadvantage—the dynamic range of transparency film is limited to about five stops, which is not sufficient to capture the range of light perceived by our eyes. In the

field, we may compensate for this shortcoming by using a two- or three-stop split neutral-density filter if a relatively straight boundary exists between the bright and dark portions of the image. Frequently, however, the demarcation between bright and dark areas is more complex than a simple horizon. The optimal solution is to expose one photograph for the highlights and another for the shadows, using appropriate exposure compensation to optimize the exposure for each of these areas. If you have only one photograph, you can try performing two scans of that transparency using different exposures, one exposed for highlights and the other for shadows.

Open the images with different exposures (whether from the field or the lab) in Photoshop and drag the darker image, exposed for the highlights, on top of the lighter one, exposed for the shadows. Reduce the opacity of the upper layer to 50% and align the images. Return the opacity of the upper layer to 100% and apply a mask to this layer. With the layer mask selected, paint with black over the shadows to selectively reveal details from the lighter image below. (Of course, one could also position the lighter image on top of the darker image and paint with black on the overexposed highlights to reveal the darker image below.) Finally, apply adjustment layers to correct tonality and color, as previously described. Now your image should appear as if it were photographed with "Super ISO" film.

ARTISTIC EFFECTS

A number of artistic effects can be produced in the digital darkroom. Several may be of particular interest to fine art photographers.

Vignette. To create a vignette effect around an image, open a copy of the image in Photoshop and select the Elliptical Marquee tool from the Toolbox (it may be hidden behind the Rectangular Marquee). Create an oval selection around the area you wish to keep, dragging the cursor and holding the Spacebar to reposition the selection as necessary (fig. 5-11a). To precisely position the selection, nudge it using the arrow keys. To soften this border, feather the edge (Select>Feather), selecting a relatively large radius (the larger the image, the larger the feather). In the example below, I selected a feather radius of 100 pixels. Preview the degree of feathering by pressing the Q key to enter Quick Mask mode (fig. 5-11b). Press Q again to return to Standard mode. Now switch the selected and unselected areas (Select>Inverse) and press the Delete key to remove the area outside the oval (fig. 5-12). If desired, place a white fill layer below the vignette layer (otherwise the surrounding area will be transparent). If your feathering was too much or too little, go to the History palette, select the state above Feather, and again choose Select>Feather to change the radius until you achieve the desired effect.

If you would like to have a background other than transparency or white surrounding the vignette, there are several options. After making your

A NUMBER OF ARTISTIC EFFECTS CAN BE PRODUCED IN THE DIGITAL DARKROOM.

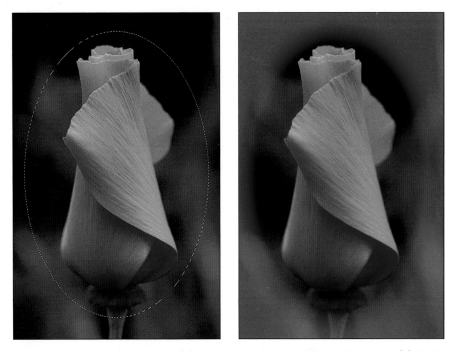

Figure 5-11. Selection for Vignette. (a) Selection applied with Elliptical Marquee. (b) Quick Mask mode was used in order to visualize the feathered selection as a mask.

selection and feathering the area, type Cmd/Ctrl J to make a copy of your selection on a new layer. Double click the Background layer and rename it to convert it to a regular layer, or make a copy of the Background layer. Now you can lower the opacity of this bottom layer or copy to reveal a vignette surrounded by a ghosted image.

AS AN ALTERNATIVE, YOU CAN DARKEN THE IMAGE SURROUNDING THE VIGNETTE.

As an alternative, you can darken the image surrounding the vignette. Make a selection to define the vignette, as described above, then inverse that selection (Select>Inverse). Create a new Solid Color fill layer (Layer> New Fill Layer>Solid Color, or click the New Layer icon at the bottom of the Layers palette) above the image and fill that layer with black (or any

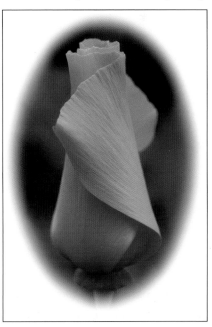

Figure 5-12. Vignette. **Left**—(a) Layers palette after deleting area to create vignette. **Right**—(b) Poppy vignette on white background. The fuzziness of the border reflects the amount of feathering applied.

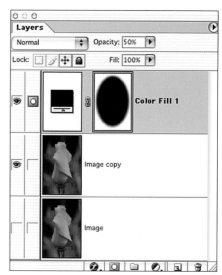

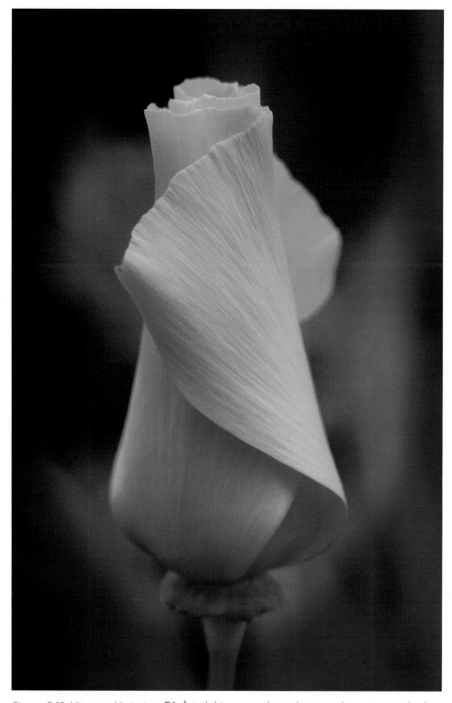

Figure 5-13. Vignette Variation. **Right**—(a) Layers palette showing alternative method to create vignette. **Above**—(b) Poppy vignette surrounded by darkened image.

color you wish). Now decrease the opacity of this layer to obscure the image around the vignette until you achieve the desired result (fig. 5-13). With this variation, I have actually applied the vignette to the layer mask for a color fill layer, rather than to the image pixels themselves. What would happen if I applied this layer mask to a white color fill layer at 100% opacity? As you can appreciate, there may be different means to achieve the same result.

Filters. *Blur.* Blending an image with a blurred copy of itself can produce an attractive softening effect. Several variations can be applied to this

theme. Some of my most creative effects have been produced with the following techniques.

Open an image of a flower, for example, and create a duplicate layer by dragging the bottom layer to the Create a New Layer icon. Highlight the upper layer, then choose Filter>Blur>Gaussian Blur and choose a radius of about 25%, which can be modified depending upon the image and the desired effect. To produce a soft painterly effect, decrease the opacity of the blurred layer to blend it with the underlying sharp layer. Initially apply a 50% opacity to the blurred layer, then increase or decrease the opacity until you achieve the desired result. The application of this technique is illustrated in the image of the poppy with a simulated canvas border (fig. 5-14).

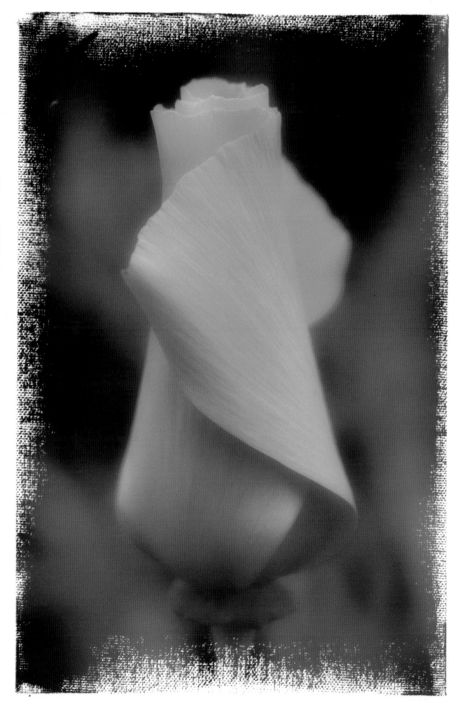

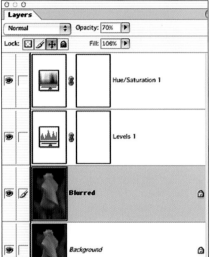

Figure 5-14. Blurred Poppy. **Above**—(a) Layers palette showing blurred duplicate layer with 70% opacity. **Right**—(b) The blurred poppy is framed with a simulated canvas texture using a third-party Photoshop plug-in.

Alternatively, instead of blurring the entire image, you could remove the blur over certain focal points. To accomplish this in a reversible manner, add a mask to the blurred layer and click on the Layer Mask icon. Type D to select default foreground color (white while on a mask), then type X to set the foreground color to black. Select the Paintbrush tool and choose a relatively small soft brush. (If you prefer, you can keep white as the foreground color and use the Eraser tool in Paintbrush mode to accomplish the same thing.) Paint over regions you want to sharpen, such as the center of

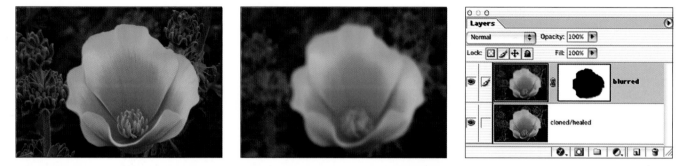

Figure 5-15. Sharp Poppy, Blurred Background. **Left**—(a) Original image. **Center**—(b) The blurred image was produced by duplicating the original image layer and applying a 20% Gaussian blur, leaving the original layer unchanged. **Right**—(c) The Layers palette shows blurred duplicate layer over the original image layer. I created a new layer mask on the blurred layer and painted with black over the areas I wanted to appear sharp. **Bottom**—(d) The image produced with this technique. To eliminate the fuzziness at the edge of the poppy, select the poppy and cut it to a new layer (Layer>New>Layer via Cut) before blurring the duplicate layer.

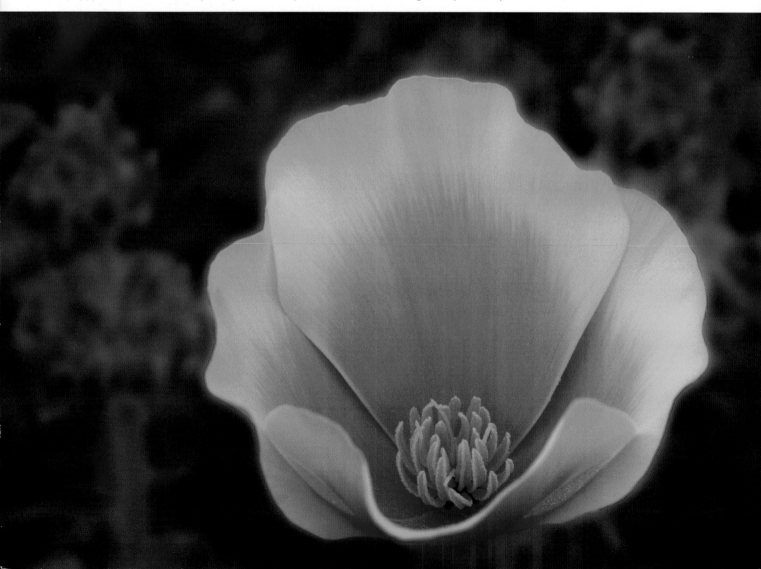

Figure 5-16. Lone Pine Filters. **Top Left**—(a) Original image. **Top Right**—(b) Monday Morning. **Bottom Left**—(c) Infrared. **Bottom Right**—(d) Pop Art.

a flower or one flower amongst others. In figure 5-15, I applied this approach to blur the flowers behind the featured poppy.

Special Effects Filters. Photoshop includes a number of other filters that can be used to apply artistic effects to fine art images. These include Artistic>Dry Brush and Pixelate>Crystallize. With any of these filters, try blending a filtered duplicate layer with the Background layer and experiment with various filter and blending settings. In addition to the default filter collection in Photoshop, various third-party software developers sell plug-in filters that work with Photoshop and some other imaging programs to produce abstract and other effects. The photographs above show the original image and diverse effects created using filters from the nik Color Efex Pro! collection.

Black & White Effects. Sometimes it is refreshing to view an image in black & white, à la Ansel Adams. I will describe three different techniques you can use for converting color images to black & white (grayscale). For each of these methods, start with a copy of your color image.

Grayscale. The most obvious way to produce a black & white image from a color one is to change the color mode from RGB to Grayscale (Image>Mode>Grayscale). This flattens your image and discards the color channels, converting it to a single gray channel. (Yes, the image could have been desaturated in RGB mode, but the effect would not be so nice.)

Create a new Levels adjustment layer and move the highlight and shadow sliders inward toward pixels on the histogram to increase contrast. Now move the midtone slider to lighten or darken the image if desired. If you wish to apply a subtle tone to the image, reconvert your image to RGB mode (Image>Mode>RGB Color), then create a new Hue/Saturation adjustment layer and check the Colorize box. Start with a Hue in the range of 20–30° and Saturation around 10% and adjust these parameters to your taste.

FOR EACH OF THESE METHODS, START WITH A COPY OF YOUR COLOR IMAGE.

Channels. Starting with an image in RGB mode, view the individual color channels (which appear as grayscale images) and highlight the one that looks best. An alternative approach is to convert the image from RGB to LAB color. All the luminosity information is contained in the L channel and the color data are in the *a* and *b* channels. Select the L channel for your grayscale image.

Now open the Channels palette menu (click the triangle at upper-right edge of the Channels palette) and select Duplicate Channel. From the dialogue box, choose New to duplicate this channel into a new document. Alternatively, if you are working on a copy of your image, you can throw away the other channels. To adjust Levels without creating an adjustment layer, click Cmd/Ctrl L. To create adjustment layers, convert the color mode from Multichannel to Grayscale and then back to RGB color. (If you are sure you will not want to add color to the image, you can keep it in Grayscale.) In addition to adjusting the contrast and brightness with Levels, you can colorize the image with a Hue/Saturation adjustment layer as described above.

Channel Mixer. The most versatile of the methods I will describe mixes varying proportions of the color channels to create a new gray channel. To utilize this technique, open the Channel Mixer (Image>Adjustments>Channel Mixer) dialogue box and check the Monochrome box (fig. 5-17a). Now adjust the percentages of the red, green, and blue source channels that will comprise the gray output channel. Preview the image RGB channels to help decide the mix. The individual RGB channel percentages may be positive or negative, but to preserve luminosity, keep the sum equal to 100%. This may require some experimentation but provides more control than the other methods discussed. If you want to save these

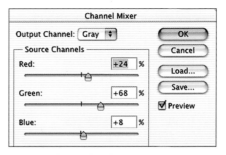

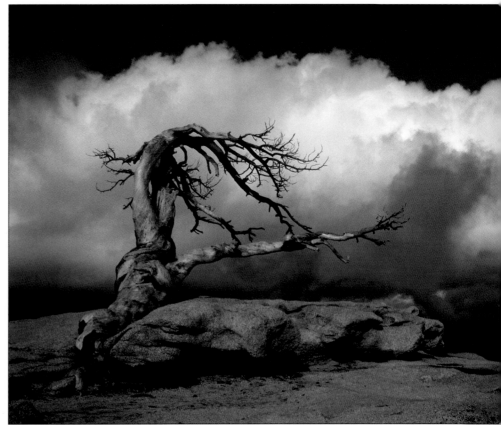

Figure 5-17. Channel Mixer Grayscale Image. **Top**—(a) Channel Mixer Dialogue Box. **Bottom**—(b) Lone Pine B&W. Applying the channel mixer settings shown to figure 5-16a yielded this image. Similar results were obtained in this instance using the L channel in LAB mode. This image now becomes the base image for applying digital darkroom techniques to create the master grayscale image.

YOU CAN USE ADJUSTMENT LAYERS TO MODIFY CONTRAST, BRIGHTNESS, AND HUES.

settings for future use, click Save on the Channel Mixer dialogue box. As with the other methods, you can use adjustment layers to modify contrast, brightness, and hues. The effect of applying this technique to the image in figure 5-16a is shown in figure 5-17b.

Color Highlight on Grayscale. One artistic technique to enhance a grayscale image is to add color to a highlight: this might be a single flower among many or the lips of a model. If the black & white image created above is not already in RGB mode, convert it using Image>Mode>RGB Color. Make a selection of the area to receive color and feather it a small amount. To colorize the entire image, follow the same procedure without creating a selection.

Choose one of the following options to select and blend the color:

1. Create a new Hue/Saturation adjustment layer and check the Colorize box. Move the Hue and Saturation sliders to select the desired color and intensity and click OK (fig. 5-18a). I used this technique to transform the image in figure 5-16a into a sepia-toned grayscale image (fig. 5-18b).

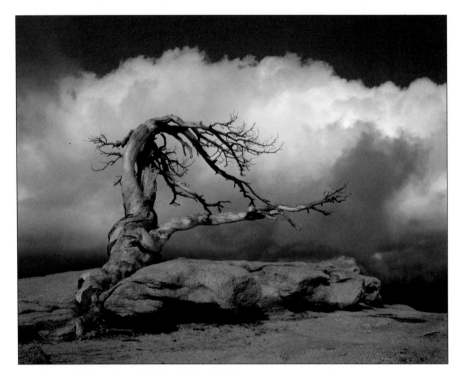

Figure 5-18. Color Highlight Grayscale Image. **Above**—(a) Hue/Saturation dialogue box. **Left**—(b) Sepia-toned image obtained by applying these Hue/Saturation settings to figure 5-16a.

2. Create a new Solid Color adjustment layer and fill it with the color of your choice from the Color Picker. Change the blending mode of this layer to Color, which creates an effect similar to the Colorize option in the Hue/Saturation adjustment layer. Decrease the opacity of the layer to achieve the desired effect (fig. 5-19).

If you want to modify a mask through which the color effect was applied, just paint on the mask with black or white. This is the beauty of using a layer mask—the selection can be adjusted or refined at any time—and the reason I prefer to use one of these methods rather than painting on image pixels with the Paintbrush in Colorize mode.

Grayscale Output. Commercial laboratories are able to produce fine quality grayscale images using the technique called piezography, which involves replacing the standard cartridges in an inkjet printer with quadtone black cartridges. You can do this at home also, but after learning the cost (about $800), you may have second thoughts—additional information is available from www.inkjetmall.com.

Less expensive options for printing black & white images include using only black ink from an inkjet printer. Unfortunately, this limits the tonal

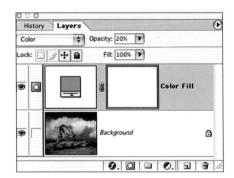

Figure 5-19. Solid Color Adjustment Layer. Images can also be colorized using a Color Fill adjustment layer with Color blending mode. Using low layer opacity produced subtle toning similar to that achieved in the previous figure.

range of the print and generally produces unsatisfactory results. Using black plus color inks seems preferable but presents a different problem: during the process of mixing color inks in an attempt to create a neutral gray, inkjet printers typically add an undesired color cast.

So what is the solution? One can either add a more desirable color cast, such as sepia toning, to the image, or use the latest generation of inkjet printers to add gray ink to the palette. As examples, the Epson Stylus Photo 2200 and its bigger siblings (7600 and 9600) produce better black & white prints than previous inkjet printers due to the addition of "light black" as a seventh color. Further enhancements in inkjet and paper technology will no doubt induce more color photographers to try their hand at digital black & white prints.

USING BLACK PLUS COLOR INKS SEEMS PREFERABLE BUT PRESENTS A DIFFERENT PROBLEM . . .

Final Thought

What a great time to be a photographer! With a moderate investment in equipment, it is now possible to produce professional-quality archival prints in your own digital darkroom by utilizing the techniques described in this book. Perhaps you are among those who have been waiting for the right time to embrace the technology of the digital darkroom. That time is now!

Index

OTHER BOOKS FROM

Amherst Media®

Big Bucks Selling Your Photography, *Revised Ed.*

Cliff Hollenbeck

A comprehensive business package. Includes starting up, pricing, creating successful portfolios, selling on the Internet, and setting financial and creative goals. Organize your business planning, bookkeeping, and taxes. $17.95 list, 8½x11, 128p, 30 b&w photos, order no. 1177.

The Beginner's Guide to Pinhole Photography

Jim Shull

Take pictures with a camera you make from stuff you have around the house. Develop and print the results at home! Pinhole photography is fun, inexpensive, educational and challenging. $17.95 list, 8½x11, 80p, 55 b&w photos, charts & diagrams, order no. 1578.

Outdoor and Location Portrait Photography
2nd Ed.

Jeff Smith

Learn to work with natural light, select locations, and make clients look their best. Packed with step-by-step discussions and illustrations to help you shoot like a pro! $29.95 list, 8½x11, 128p, 80 color photos, index, order no. 1632.

Profitable Portrait Photography

Roger Berg

A step-by-step guide to making money in portrait photography. Combines information on portrait photography with detailed business plans to form a comprehensive manual for starting or improving your business. $29.95 list, 8½x11, 104p, 100 b&w and color photos, index, order no. 1570.

Freelance Photographer's Handbook

Cliff and Nancy Hollenbeck

Whether you want to be a freelance photographer or are looking for tips to improve your current freelance business, this volume is packed with ideas for creating and maintaining a successful freelance business. $29.95 list, 8½x11, 107p, 100 b&w and color photos, index, glossary, order no. 1633.

Professional Secrets for Photographing Children
2nd Ed.

Douglas Allen Box

Covers every aspect of photographing children, from preparing them for the shoot, to selecting the right clothes to capture a child's personality, and shooting storybook themes. $29.95 list, 8½x11, 128p, 80 color photos, index, order no. 1635.

Fashion Model Photography

Billy Pegram

For the photographer interested in shooting commercial model assignments, or working with models to create portfolios. Includes techniques for dramatic composition, posing, selection of clothing, and more! $29.95 list, 8½x11, 120p, 58 b&w and color photos, index, order no. 1640.

Handcoloring Photographs Step by Step

Sandra Laird and Carey Chambers

Learn to handcolor photographs step-by-step with the new standard in handcoloring reference books. Covers a variety of coloring media and techniques. $29.95 list, 8½x11, 112p, 100 b&w and color photos, order no. 1543.

Creating World-Class Photography

Ernst Wildi

Learn how any photographer can create technically flawless photos. Features techniques for eliminating technical flaws in all types of photos—from portraits to landscapes. Includes the Zone System, digital imaging, and much more. $29.95 list, 8½x11, 128p, 120 color photos, index, order no. 1718.

Family Portrait Photography

Helen Boursier

Learn from professionals how to operate a successful studio. Includes: marketing family portraits, working with clients, posing, lighting, and selection of equipment. Includes images from a variety of top portrait shooters. $29.95 list, 8½x11, 120p, 120 b&w and color photos, index, order no. 1629.

The Art of Infrared Photography, 4th Ed.

Joe Paduano

A practical guide to infrared photography. Tells what to expect and how to control results. Includes: anticipating effects, color infrared, digital infrared, using filters, focusing, developing, printing, handcoloring, toning, and more! $29.95 list, 8½x11, 112p, 70 b&w photos, order no. 1052.

Essential Skills for Nature Photography

Cub Kahn

Learn the skills you need to capture landscapes, animals, flowers, and the entire natural world on film. Includes: selecting equipment, choosing locations, evaluating compositions, filters, and much more! $29.95 list, 8½x11, 128p, 60 b&w and color photos, order no. 1652.

Photographer's Guide to Polaroid Transfer, 2nd Ed.

Christopher Grey

Step-by-step instructions make it easy to master Polaroid transfer and emulsion lift-off techniques and add new dimension to your photographic imaging. Fully illustrated to ensure great results the first time! $29.95 list, 8½x11, 128p, 100 color photos, order no. 1653.

Wedding Photojournalism

Andy Marcus

Learn to create dramatic unposed wedding portraits. Working through the wedding from start to finish, you'll learn where to be, what to look for, and how to capture it. $29.95 list, 8½x11, 128p, 60 b&w photos, order no. 1656.

Professional Secrets of Wedding Photography 2nd Ed.

Douglas Allen Box

Top-quality portraits are analyzed to teach you the art of professional wedding portraiture. Lighting diagrams, posing information, and technical specs are included for every image. $29.95 list, 8½x11, 128p, 80 color photos, order no. 1658.

Photographer's Guide to Shooting Model & Actor Portfolios

C J Elfont, Edna Elfont, and Alan Lowy

Create outstanding images for actors and models looking for work in fashion, theater, television, or the big screen. Includes the business and photo techniques you need! $29.95 list, 8½x11, 128p, 100 b&w and color photos, order no. 1659.

Photo Retouching with Adobe® Photoshop® 2nd Ed.

Gwen Lute

Teaches every phase of the process, from scanning to final output. Learn to restore damaged photos, correct imperfections, create realistic composite images, and correct for dazzling color. $29.95 list, 8½x11, 120p, 100 color images, order no. 1660.

Creative Lighting Techniques for Studio Photographers, 2nd Ed.

Dave Montizambert

Whether you are shooting portraits, cars, tabletop, or any other subject, Dave Montizambert teaches you the skills you need to take complete control of your lighting. $29.95 list, 8½x11, 120p, 80 color photos, order no. 1666.

Storytelling Wedding Photography

Barbara Box

Barbara and her husband shoot as a team at weddings. Here, she shows you how to create outstanding candids (her specialty), and combine them with formals (her husband's specialty) to create unique wedding albums. $29.95 list, 8½x11, 128p, 60 b&w photos, order no. 1667.

Infrared Portrait Photography

Richard Beitzel

Discover the unique beauty of infrared portraits, and learn to create them yourself. Included is information on: shooting with infrared, selecting subjects and settings, filtration, lighting, and much more! $29.95 list, 8½x11, 128p, 60 b&w photos, order no. 1669.

Marketing and Selling Black & White Portrait Photography

Helen T. Boursier

Complete manual for adding b&w portraits to the products you offer clients (or offering exclusively b&w). Learn to attract clients and deliver portraits that will keep them coming back. $29.95 list, 8½x11, 128p, 80 b&w photos, order no. 1677.

Secrets of Successful Aerial Photography

Richard Eller

Learn how to plan a shoot and take images from the air. Discover how to control camera movement, compensate for environmental conditions and compose outstanding aerial images. $29.95 list, 8½x11, 120p, 100 b&w and color photos, order no. 1679.

Professional Secrets of Nature Photography

Judy Holmes

Covers every aspect of making top-quality images, from selecting the right equipment, to choosing the best subjects, to shooting techniques for professional results every time. $29.95 list, 8½x11, 120p, 100 color photos, order no. 1682.

Composition Techniques from a Master Photographer

Ernst Wildi

Composition can make the difference between dull and dazzling. Master photographer Ernst Wildi teaches you his techniques for evaluating subjects and composing powerful images in this beautiful color book. $29.95 list, 8½x11, 128p, 100 color photos, order no. 1685.

Macro & Close-up Photography Handbook

Stan Sholik and Ron Eggers

Learn to get close and capture breathtaking images of small subjects—flowers, stamps, jewelry, insects, etc. Designed with the 35mm shooter in mind, this is a comprehensive manual full of step-by-step techniques. $29.95 list, 8½x11, 120p, 80 b&w and color photos, order no. 1686.

Corrective Lighting and Posing Techniques for Portrait Photographers

Jeff Smith

Learn to make every client look his or her best by using lighting and posing to conceal real or imagined flaws—from baldness, to acne, to figure flaws. $29.95 list, 8½x11, 120p, 150 color photos, order no. 1711.

Professional Secrets of Natural Light Portrait Photography

Douglas Allen Box

Use natural light to create hassle-free portraiture. Beautifully illustrated with detailed instructions on equipment, lighting, and posing. $29.95 list, 8½x11, 128p, 80 color photos, order no. 1706.

Professional Marketing & Selling Techniques for Wedding Photographers

Jeff Hawkins and Kathleen Hawkins

Learn the business of wedding photography. Includes consultations, direct mail, advertising, internet marketing, and much more. $29.95 list, 8½x11, 128p, 80 color photos, order no. 1712.

Photographing Creative Landscapes

Michael Orton

Boost your creativity and bring a new level of enthusiasm to your images of the landscape. This step-by-step guide is the key to escaping from your creative rut and beginning to create more expressive images. $29.95 list, 8½x11, 128p, 70 color photos, order no. 1714.

Advanced Infrared Photography Handbook

Laurie White Hayball

Building on the techniques covered in her *Infrared Photography Handbook*, Laurie White Hayball presents advanced techniques for harnessing the beauty of infrared light on film. $29.95 list, 8½x11, 128p, 100 b&w photos, order no. 1715.

Zone System

Brian Lav

Learn to create perfectly exposed black & white negatives and top-quality prints. With this step-by-step guide, anyone can learn the Zone System and gain complete control of their black & white images! $29.95 list, 8½x11, 128p, 70 b&w photos, order no. 1720.

Selecting and Using Classic Cameras

Michael Levy

Discover the charms and challenges of using classic cameras. Folders, TLRs, SLRs, Polaroids, rangefinders, spy cameras, and more are included in this gem for classic camera lovers. $17.95 list, 6x9, 196p, 90 b&w photos, order no. 1719.

Traditional Photographic Effects with Adobe® Photoshop®, 2nd Ed.

Michelle Perkins and Paul Grant

Use Photoshop to enhance your photos with handcoloring, vignettes, soft focus, and much more. Every technique contains step-by-step instructions for easy learning. $29.95 list, 8½x11, 128p, 150 color images, order no. 1721.

Master Posing Guide for Portrait Photographers

J. D. Wacker

Learn the techniques you need to pose single portrait subjects, couples, and groups for studio or location portraits. Includes techniques for photographing weddings, teams, children, special events and much more. $29.95 list, 8½x11, 128p, 80 photos, order no. 1722.

Photographic Lenses
PHOTOGRAPHER'S GUIDE TO CHARAC-
TERISTICS, QUALITY, USE AND DESIGN

Ernst Wildi

Gain a complete understanding of the lenses through which all photographs are made—both on film and in digital photography. $29.95 list, 8½x11, 128p, 70 color photos, order no. 1723.

The Art of Color Infrared Photography

Steven H. Begleiter

Color infrared photography will open the doors to a new and exciting photographic world. This book shows readers how to previsualize the scene and get the results they want. $29.95 list, 8½x11, 128p, 80 color photos, order no. 1728.

The Art of Photographing Water

Cub Kahn

Learn to capture the interplay of light and water with this beautiful, compelling, and comprehensive book. Packed with practical information you can use right away! $29.95 list, 8½x11, 128p, 70 color photos, order no. 1724.

High Impact Portrait Photography

Lori Brystan

Learn how to create the high-end, fashion-inspired portraits your clients will love. Features posing, alternative processing, and much more. $29.95 list, 8½x11, 128p, 60 color photos, order no. 1725.

Legal Handbook for Photographers

Bert P. Krages, Esq.

This book offers examples that illustrate the *who, what, when, where* and *why* of problematic subject matter, putting photographers at ease to shoot without fear of liability. $19.95 list, 8½x11, 128p, 40 b&w photos, order no. 1726.

Digital Imaging for the Underwater Photographer

Jack and Sue Drafahl

This book will teach readers how to improve their underwater images with digital imaging techniques. This book covers all the bases—from color balancing your monitor, to scanning, to output and storage. $39.95 list, 6x9, 224p, 80 color photos, order no. 1727.

The Art of Bridal Portrait Photography

Marty Seefer

Learn to give every client your best and create timeless images that are sure to become family heirlooms. Seefer takes readers through every step of the bridal shoot, ensuring flawless results. $29.95 list, 8½x11, 128p, 70 color photos, order no. 1730.

Photographer's Filter Handbook

Stan Sholik and Ron Eggers

Take control of your photography with the tips offered in this book! This comprehensive volume teaches readers how to color-balance images, correct contrast problems, create special effects, and more. $29.95 list, 8½x11, 128p, 100 color photos, order no. 1731.

Beginner's Guide to Adobe® Photoshop®, 2nd Ed.

Michelle Perkins

Learn to effectively make your images look their best, create original artwork, or add unique effects to any image. Topics are presented in short, easy-to-digest sections that will boost confidence and ensure outstanding images. $29.95 list, 8½x11, 128p, 300 color images, order no. 1732.

Professional Techniques for Digital Wedding Photography, 2nd Ed.

Jeff Hawkins and Kathleen Hawkins

From selecting equipment, to marketing, to building a digital workflow, this book teaches how to make digital work for you. $29.95 list, 8½x11, 128p, 85 color images, order no. 1735.

Lighting Techniques for High Key Portrait Photography

Norman Phillips

Learn to meet the challenges of high key portrait photography and produce images your clients will adore. $29.95 list, 8½x11, 128p, 100 color photos, order no. 1736.

Photographer's Lighting Handbook

Lou Jacobs Jr.

Think you need a room full of expensive lighting equipment to get great shots? With a few simple techniques and basic equipment, you can produce the images you desire. $29.95 list, 8½x11, 128p, 130 color photos, order no. 1737.

Professional Digital Photography

Dave Montizambert

From monitor calibration, to color balancing, to creating advanced artistic effects, this book provides those skilled in basic digital imaging with the techniques they need to take their photography to the next level. $29.95 list, 8½x11, 128p, 120 color photos, order no. 1739.

Group Portrait Photographer's Handbook

Bill Hurter

With images by top photographers, this book offers timeless techniques for composing, lighting, and posing group portraits. $29.95 list, 8½x11, 128p, 120 color photos, order no. 1740.

LIGHTING AND EXPOSURE TECHNIQUES FOR
Outdoor and Location Portrait Photography

J. J. Allen

Meet the challenges of changing light and complex settings with techniques that help you achieve great images every time. $29.95 list, 8½x11, 128p, 150 color photos, order no. 1741.

Toning Techniques for Photographic Prints

Richard Newman

Whether you want to age an image, provide a shock of color, or lend archival stability to your black & white prints, the step-by-step instructions in this book will help you realize your creative vision. $29.95 list, 8½x11, 128p, 150 color and b&w photos, order no. 1742.

The Art and Business of High School Senior Portrait Photography

Ellie Vayo

Learn the techniques that have made Ellie Vayo's studio one of the most profitable senior portrait businesses in the US. $29.95 list, 8½x11, 128p, 100 color photos, order no. 1743.

The Best of Nature Photography

Jenni Bidner and Meleda Wegner

Ever wondered how legendary nature photographers like Jim Zuckerman and John Sexton create their images? Follow in their footsteps as top photographers capture the beauty and drama of nature on film. $29.95 list, 8½x11, 128p, 150 color photos, order no. 1744.

Beginner's Guide to Nature Photography

Cub Kahn

Whether you prefer a walk through a neighborhood park or a hike through the wilderness, the beauty of nature is ever present. Learn to create images that capture the scene as you remember it with the simple techniques found in this book. $14.95 list, 6x9, 96p, 70 color photos, order no. 1745.

Photo Salvage with Adobe® Photoshop®

Jack and Sue Drafahl

This book teaches you to digitally restore faded images and poor exposures. Also covered are techniques for fixing color balance problems and processing errors, eliminating scratches, and much more. $29.95 list, 8½x11, 128p, 200 color photos, order no. 1751.

The Art of Black & White Portrait Photography

Oscar Lozoya

Learn how Master Photographer Oscar Lozoya uses unique sets and engaging poses to create black & white portraits that are infused with drama. Includes lighting strategies, special shooting techniques and more. $29.95 list, 8½x11, 128p, 100 duotone photos, order no. 1746.

The Best of Wedding Photography

Bill Hurter

Learn how the top wedding photographers in the industry transform special moments into lasting romantic treasures with the posing, lighting, album design, and customer service pointers found in this book. $29.95 list, 8½x11, 128p, 150 color photos, order no. 1747.

Photographing Children with Special Needs

Karen Dórame

This book explains the symptoms of spina bifida, autism, cerebral palsy, and more, teaching photographers how to safely and effectively capture the unique personalities of these children. $29.95 list, 8½x11, 128p, 100 color photos, order no. 1749.

Professional Digital Portrait Photography

Jeff Smith

Because the learning curve is so steep, making the transition to digital can be frustrating. Author Jeff Smith shows readers how to shoot, edit, and retouch their images—while avoiding common pitfalls. $29.95 list, 8½x11, 128p, 100 color photos, order no. 1750.

The Best of Children's Portrait Photography

Bill Hurter

Rangefinder editor Bill Hurter draws upon the experience and work of top professional photographers, uncovering the creative and technical skills they use to create their magical portraits. $29.95 list, 8½x11, 128p, 150 color photos, order no. 1752.

Wedding Photography with Adobe® Photoshop®

Rick Ferro and Deborah Lynn Ferro

Get the skills you need to make your images look their best, add artistic effects, and boost your wedding photography sales with savvy marketing ideas. $29.95 list, 8½x11, 128p, 100 color images, index, order no. 1753.

Web Site Design for Professional Photographers

Paul Rose and Jean Holland-Rose

Learn to design, maintain, and update your own photography web site. Designed for photographers, this book shows you how to create a site that will attract clients and boost your sales. $29.95 list, 8½x11, 128p, 100 color images, index, order no. 1756.

PROFESSIONAL PHOTOGRAPHER'S GUIDE TO
Success in Print Competition

Patrick Rice

Learn from PPA and WPPI judges how you can improve your print presentations and increase your scores. $29.95 list, 8½x11, 128p, 100 color photos, index, order no. 1754.

Advanced Digital Camera Techniques

Jack and Sue Drafahl

Maximize the quality and creativity of your digital-camera images with the techniques in this book. Packed with problem-solving tips and ideas for unique images. $29.95 list, 8½x11, 128p, 150 color photos, index, order no. 1758.

PHOTOGRAPHER'S GUIDE TO
Wedding Album Design and Sales

Bob Coates

Enhance your income and creativity with these techniques from top wedding photographers. $29.95 list, 8½x11, 128p, 150 color photos, index, order no. 1757.

The Best of Portrait Photography

Bill Hurter

View outstanding images from top professionals and learn how they create their masterful images. Includes techniques for classic and contemporary portraits. $29.95 list, 8½x11, 128p, 200 color photos, index, order no. 1760.

THE ART AND TECHNIQUES OF
Business Portrait Photography

Andre Amyot

Learn the business and creative skills photographers need to compete successfully in this challenging field. $29.95 list, 8½x11, 128p, 100 color photos, index, order no. 1762.

Creative Techniques for Color Photography

Bobbi Lane

Learn how to render color precisely, whether you are shooting digitally or on film. Also includes creative techniques for cross processing, color infrared, and more. $29.95 list, 8½x11, 128p, 250 color photos, index, order no. 1764.

The Bride's Guide to Wedding Photography

Kathleen Hawkins

Learn how to get the wedding photography of your dreams with tips from the pros. Perfect for brides or wedding photographers who want their clients to look their best. $14.95 list, 9x6, 112p, 115 color photos, index, order no. 1755.

The Best of Teen and Senior Portrait Photography

Bill Hurter

Learn how top professionals create stunning images that capture the personality of their teen and senior subjects. $29.95 list, 8½x11, 128p, 150 color photos, index, order no. 1766.

PHOTOGRAPHER'S GUIDE TO
The Digital Portrait

START TO FINISH WITH ADOBE® PHOTOSHOP®

Al Audleman

Follow through step-by-step procedures to learn the process of digitally retouching a professional portrait. $29.95 list, 8½x11, 128p, 120 color images, index, order no. 1771.

The Portrait Book
A GUIDE FOR PHOTOGRAPHERS

Steven H. Begleiter

A comprehensive textbook for those getting started in professional portrait photography. Covers every aspect from designing an image to executing the shoot. $29.95 list, 8½x11, 128p, 130 color images, index, order no. 1767.

The Master Guide for Wildlife Photographers

Bill Silliker, Jr.

Discover how photographers can employ the techniques used by hunters to call, track, and approach animal subjects. Includes safety tips for wildlife photo shoots. $29.95 list, 8½x11, 128p, 100 color photos, index, order no. 1768.

Heavenly Bodies
THE PHOTOGRAPHER'S GUIDE TO ASTROPHOTOGRAPHY

Bert P. Krages, Esq.

Learn to capture the beauty of the night sky with a 35mm camera. Tracking and telescope techniques are also covered. $29.95 list, 8½x11, 128p, 100 color photos, index, order no. 1769.

Digital Photography for Children's and Family Portraiture

Kathleen Hawkins

Discover how digital photography can boost your sales, enhance your creativity, and improve your studio's workflow. $29.95 list, 8½x11, 128p, 130 color images, index, order no. 1770.

Professional Strategies and Techniques for Digital Photographers

Bob Coates

Learn how professionals—from portrait artists to commercial specialists—enhance their images with digital techniques. $29.95 list, 8½x11, 128p, 130 color photos, index, order no. 1772.

Lighting Techniques for Low Key Portrait Photography

Norman Phillips

Learn to create the dark tones and dramatic lighting that typify this classic portrait style. $29.95 list, 8½x11, 128p, 100 color photos, index, order no. 1773.

The Best of Wedding Photojournalism

Bill Hurter

Learn how top professionals capture these fleeting moments of laughter, tears, and romance. Features images from over twenty renowned wedding photographers. $29.95 list, 8½x11, 128p, 150 color photos, index, order no. 1774.

Color Correction and Enhancement with Adobe® Photoshop®

Michelle Perkins

Master precision color correction and artistic color enhancement techniques for scanned and digital photos. $29.95 list, 8½x11, 128p, 300 color images, index, order no. 1776.

Fantasy Portrait Photography

Kimarie Richardson

Learn how to create stunning portraits with fantasy themes—from fairies and angels, to 1940s glamour shots. Includes portrait ideas for infants through adults. $29.95 list, 8½x11, 128p, 60 color photos index, order no. 1777.

MORE PHOTO BOOKS ARE AVAILABLE

Amherst Media®
PO BOX 586
BUFFALO, NY 14226 USA

INDIVIDUALS: If possible, purchase books from an Amherst Media retailer. Contact us for the dealer nearest you, or visit our web site and use our dealer locater. To order direct, visit our web site, or send a check/money order with a note listing the books you want and your shipping address. All major credit cards are also accepted. For domestic and international shipping rates, please visit our web site or contact us at the numbers listed below. New York state residents add 8% sales tax.

DEALERS, DISTRIBUTORS & COLLEGES: Write, call, or fax to place orders. For price information, contact Amherst Media or an Amherst Media sales representative. Net 30 days.

(800)622-3278 or (716)874-4450
FAX: (716)874-4508

All prices, publication dates, and specifications are subject to change without notice. Prices are in U.S. dollars. Payment in U.S. funds only.

WWW.AMHERSTMEDIA.COM
FOR A COMPLETE CATALOG OF BOOKS AND ADDITIONAL INFORMATION